MAKING THEIR MARK
Irish Painter-Etchers 1880–1930

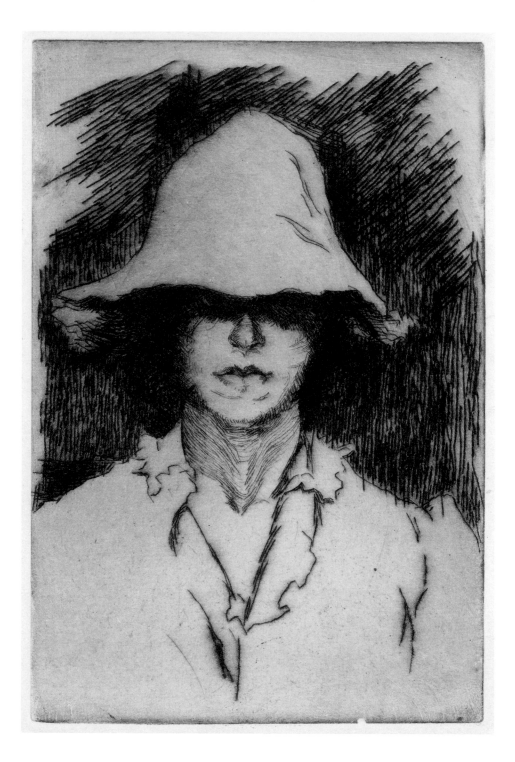

MAKING THEIR MARK

Irish Painter-Etchers
1880–1930

Angela Griffith
Anne Hodge

NATIONAL GALLERY OF IRELAND

Kindly supported by:

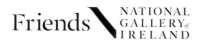

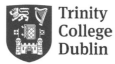

page 2
Estella Solomons (1882–1968)
Self-Portrait
Trinity College Dublin, TCD MS 11583/2018/19

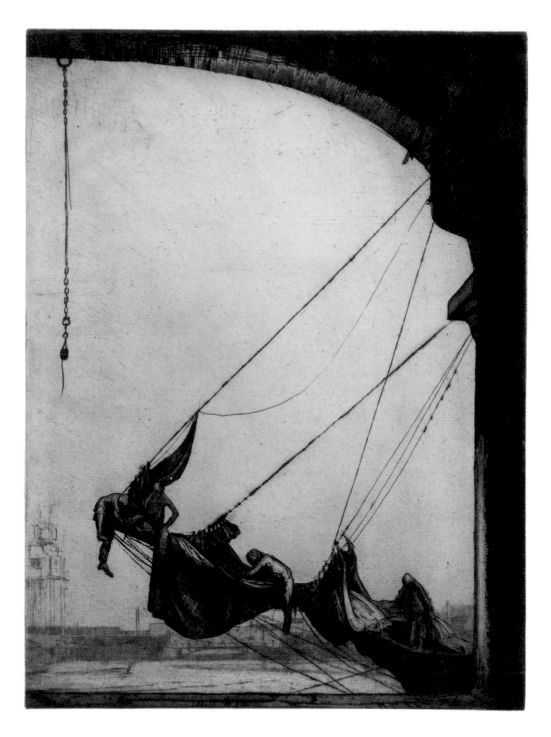

Percy F. Gethin (1874–1916)
Bending the Jib, c. 1912
The British Museum,
PD 1924,0209.18, donated by
The Contemporary Art Society

FOREWORD

Holding collections of Irish art, such as that held by the National Gallery of Ireland, comes with a duty to illuminate all corners of the fruits of artistic endeavour. One of the lesser-known aspects of Irish art, explored through the works in this ground-breaking exhibition, is printmaking by Irish artists. During the latter part of the nineteenth century and first decades of the following one, Irish artists recognised a deficit in their own tradition and sought to close the gap through studies with printmakers in England and on the European continent. A distinctively Irish sensibility appeared relatively late, perhaps most visibly with the inner-city images created by Estella Frances Solomons in the early years of the last century.

Many Irish artists, amateur and professional, contributed to the revival of printmaking as a form of independent, creative expression. Unshackled from its duties as a primarily reproductive medium, making copies of paintings for wide distribution or material for illustrating periodicals, printmaking flourished as an artistic medium by the mid-nineteenth century. Etching proved the most individualistic of techniques, given unique status by French, then British and, latterly, Irish artists towards the turn of the nineteenth century. This exhibition explores that legacy.

For their curatorial expertise in assembling rare, sometimes unique loans for this exhibition, I would like to thank Anne Hodge, our Curator of Prints and Drawings, and her co-curator Dr Angela Griffith from Trinity College Dublin, for their close collaboration and dedication. They have charted the emergence of independent printmaking by Irish artists, an underappreciated area until now, but nevertheless one of the foundations for the presence of important printmaking workshops in Dublin, Cork, Belfast and Limerick in our own times. The Gallery has in recent years begun to address the gaps in its collection in terms of printmaking, acquiring significant works by Irish artists including exciting new work by contemporary artists.

I would like to thank them both for their insightful essays in the catalogue that accompanies this exhibition. It has received generous support from TRIARC, TCD and from the Friends of the National Gallery of Ireland. This project testifies to the supportive relationship between our respective institutions. The curators will wish to join me in thanking the many lenders to the exhibition. Without their support this exhibition could not have happened. Our colleagues at the Gallery – in Curatorial, Conservation, Exhibitions, Education, Communications, Visitor Experience and many other departments – have all contributed towards its success. As has the steadfast support of the Gallery's Board of Governors & Guardians. My gratitude goes to them all.

Sean Rainbird
Director, National Gallery of Ireland

PRINTS IN THE NATIONAL GALLERY OF IRELAND

Historically, Ireland has lagged behind its European neighbours in terms of printmaking and collecting. With rare exceptions, Irish printmakers did not have a significant presence until the mid-twentieth century. The work of the painter-etchers, artists who created original prints rather than commercial reproductions or translations of paintings, was not recognised or appreciated. The absence of editioning in Ireland until the 1960s, when the first co-operative print studio Graphic Studio Dublin was founded, points to a general lack of interest and a small market for prints.

The National Gallery of Ireland did not collect prints with any enthusiasm until well after its foundation in 1854. When the building opened to the public in January 1864 there were no prints on display (fig.1). For the first twenty years of its history the Gallery received occasional donations of reproductive engravings after Old Master paintings, for example in 1884 C.R. Howard, 6th Earl of Wicklow, gifted two seventeenth-century prints by Romeyn de Hooghe depicting William of Orange's triumphs in Ireland. It was not until that year, when the Gallery's second director Henry Doyle instigated a 'Historical and Portrait' section, that prints began to be collected with purpose. From that time collections of reproductive prints by Irish artists and engravers and prints depicting important Irish personages were acquired. In 1887 and 1888, thanks to a gift of £1000 from Sir Edward Guinness, some 300 eighteenth- and early nineteenth-century mezzotint portraits were bought at the Chaloner Smith Sales.[1] This acquisition, which included prints by distinguished 'Dublin Group' mezzotinters including McArdell, Brooks, Miller and Houston, formed the nucleus of the National Gallery of Ireland's print collection. In 1898 another important collection of prints of Irish interest was bought from a Mr P. Traynor, mainly reproductive prints after eighteenth-century artists including John Comerford and Adam Buck.

Despite the fact that the painter-etcher movement was well established by the 1880s (and the Dublin Sketching Club exhibited James Abbott McNeill Whistler's prints at some of their exhibitions), the Gallery did not acquire any original prints by contemporary artists until 1902. In that year, Dr W. Booth Pearsall, a founder member of the Dublin Sketching Club and organiser of the Whistler exhibition, gifted eighteen small etchings by fellow member Reverend William Fitzgerald to the Gallery. In 1904 Sarah Cecilia Harrison, a Dublin-born portraitist of note who had studied under Professor Alphonse Legros at the Slade, presented Legros's series of etchings *Triumph of Death* (see page 15) to the Gallery. Small numbers of original etchings came into the Gallery singly or in small groups over a long period: Percy Gethin's *South German Farm* was donated by Mrs G. Lane in 1919 while the other Gethin etchings in the collection were gifted by Gethin's friend and colleague Fred V. Burridge in 1926. Burridge had met Gethin when they were both working in the art school in Liverpool. When

1 John Chaloner Smith (1827–95) was an Irish railway engineer who sold his important collection of mezzotints at Sotheby's. He published a four-volume catalogue of the collection: *British Mezzotinto Portraits … with Biographical Notes* (London, 1878–84).

Burridge was appointed Principal of the Central School of Arts and Crafts in London, Gethin got a teaching post there too. A letter dated 28th June 1926 from Burridge to Sarah Purser explains that he is sending her four proofs of Gethin's etchings 'for inclusion in the Gallery or Museum in Dublin which you would consider best suited to house them'. Poignantly, he writes that Gethin was killed in France on the same date in 1916.[2] Purser, a key figure in Irish cultural life, had founded the Friends of the National Collections (an organisation to assist Irish museums to acquire works of art) in 1924. Sixteen prints by Joseph Pennell were donated by a New York-based woman, Mrs C. White, in 1937 and ten years later The Sickert Trust donated 12 etchings by Walter Sickert (fig. 2) along with six etchings by Sickert's wife Thérèse Lessore.

2 Dossier file: NGI 11429.

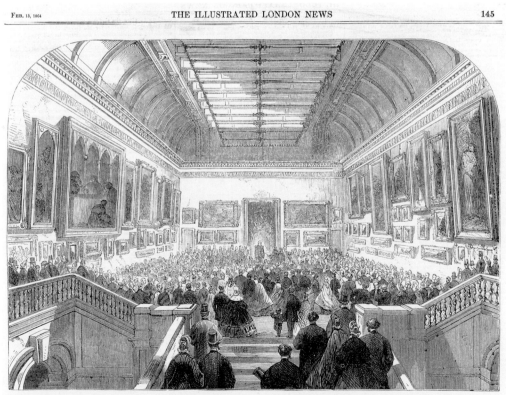

HIS EXCELLENCY THE EARL OF CARLISLE OPENING THE NATIONAL GALLERY OF IRELAND.—SEE PAGE 151.

fig. 1

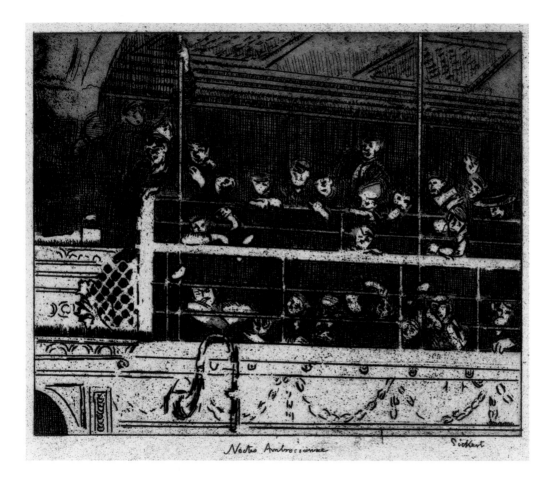

fig. 2

Walter Sickert (1860–1942)

Noctes Ambrosianae c. 1908

The establishment of a municipal gallery of modern art in 1908 (now Hugh Lane Gallery) may have contributed to the fact that so few original prints were acquired by the National Gallery of Ireland in the twentieth century. The city of Dublin now had a gallery for contemporary art, both home-grown and European. In 1912 Sir Hugh Lane gifted a collection of works to the fledgling gallery including a group of etchings by the French artist Alphonse Legros. Legros himself presented an etching entitled *The Death of the Vagrant*, while Sarah Cecilia Harrison, who worked closely with Hugh Lane to establish the gallery, presented one of her own etchings *Study of a Man's Head* (see page 43), along with prints by her teacher Legros and William Strang, another notable painter-etcher. Etchings by other significant Irish printmakers including George Atkinson and Edward Lawrenson were acquired by the Hugh Lane Gallery, often as gifts from the artist, in the early decades of the twentieth century.

On my appointment as Curator of Prints and Drawings at the National Gallery of Ireland in 2002, I quickly became aware of gaps in the collection, particularly in the area of print. Since then the Gallery has acquired over 700 prints across techniques. Notable highlights include: a collection of over 70 prints by Swedish printmakers including Anders Zorn (2006); five etchings made by Roderic O'Conor in the early 1890s (2009 and 2012); the Brian Lalor Print Collection which includes etchings by important European printmakers such as Félix Bracquemond, Dame Laura Knight, Hubert von Herkomer and Jozef Israels (2014); a group of six delicate drypoints by Berthe Morisot (2014); two richly etched prints by Frank Brangwyn (2011 and 2016); plus prints by Irish artists including Sean O'Sullivan, Hilda van Stockum, Elizabeth Rivers and John Luke. Unlike the early twentieth century when the NGI did not collect new work by the printmakers of the day, we are now actively acquiring work being produced by vibrant print studios around the country. We have purchased Graphic Studio Dublin's annual Sponsor's Portfolios since 2010, and in 2020 will hold the complete set. Prints by significant Irish artists including Dorothy Cross and Brian O'Doherty printed by Stoney Road Press were acquired in 2018 and most recently twelve prints by members of Cork Print-Makers, including an etching by Fiona Kelly, have entered the collection (fig.3).

In order to bring this fascinating aspect of art to the attention of diverse audiences, many of our exhibitions have focused specifically on prints: *What is a Print?* (2006); *Revelation* (new prints inspired by the NGI collection by Graphic Studio Dublin members) (2008); *Eclectic Images: The Brian Lalor Print Collection* (2016); *Käthe Kollwitz: Life, Death and War* (2017); *Good Morning Mr. Turner: Niall Naessens and J.M.W. Turner* (2018). In 2019 we will show *Bauhaus 100: the Print Portfolios* while in 2020 the exhibition *Best Face Forward: the Prints of George Wallace (1920–2009)* will feature highlights from a wonderful collection of prints by an Irish-Canadian artist, presented by the artist's family in 2016.

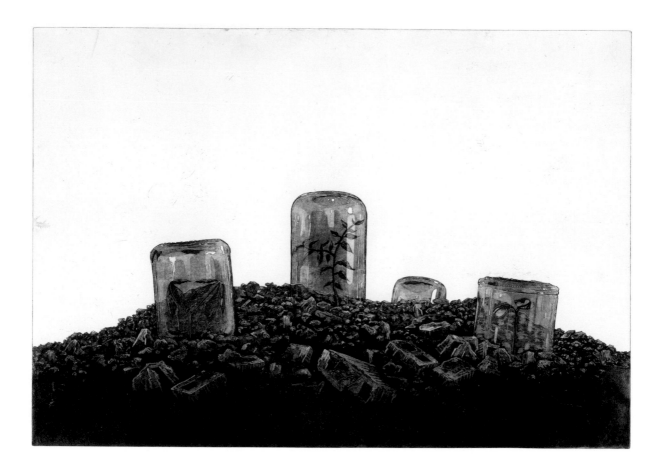

fig.3
Fiona Kelly (b. 1985)
Future Forests, 2018

NGI, recent acquisition

fig. 4

3 These cases were designed
and installed in February
2018 by Meyvaert, a company
based in Ghent, Belgium.

The Prints and Drawings Study Room provides a space where material can be safely viewed by researchers. To ensure that prints and other works on paper can be enjoyed by our general visitors we have been commited to maintaining our purpose-built Print Gallery, which first opened in 1996. In 2017/2018 a major capital project was approved for new display cases (fig. 4). These custom-built cases with non-reflective, UV filtered glass, and LED lighting systems, allow us to show prints and drawings to best advantage.[3] At a time when many public museums internationally are doing away with purpose-built galleries for works on paper, this investment underlines how important we believe this part of the national collection to be. We aim to continue to build our collection of prints so that future generations of visitors and researchers will be able to enjoy and use the collections and form a clear picture of the history of printmaking in Ireland and its European influences.

Anne Hodge
Curator of Prints and Drawings, National Gallery of Ireland

MAKING THEIR MARK
Irish Painter-Etchers and the Etching Revival

Introduction

A 1919 *Freeman's Journal* exhibition review of work by Dublin-based artists Estella Solomons and Mary Duncan stated that etchings 'though rare as blackberries in December, are rare enough to rouse wonder as to why so expressive an art should receive so little encouragement in our midst'.[1] This quotation provides some insight into the attitudes towards the art of original printmaking in Ireland in the first decades of the twentieth century. While the rest of Britain, Europe and the United States of America were in the midst of the so-called 'Print Boom' – which saw leading international artists of the day making fine art prints for an appreciative and expanding art market – a majority of Irish artists did not adopt the medium. However, despite a lack of universal uptake in Ireland, there was a small, but dedicated, group of artists who explored the creative possibilities of the etcher's needle.

This National Gallery of Ireland exhibition, *Making their Mark: Irish Painter-Etchers 1880–1930*, represents the first-ever presentation and contextualisation of fine art etching in Ireland from 1880 to 1930. At no point in the history of Irish art has there been a public display dedicated to modernist etching. While this is not an exhaustive survey of all painter-etchers with Irish connections, those included demonstrated a commitment to the medium of original printmaking. They received recognition for their work in their own lifetimes, and produced significant works of artistic and cultural merit.

Given the fact that original printmaking did not flourish in Ireland, it is unsurprising that the majority of Irish artists who elected to work in etching found their inspiration, their training and recognition abroad. Working in a medium that was thriving elsewhere, Irish painter-etchers looked to the tenets of the Etching Revival movement, thus ensuring they were actively engaged with international modernist theories and practices.

The Etching Revival

France was acknowledged by contemporary critics as the birthplace of the Modern Etching Revival, a movement that stretched from the middle of the 1800s to the first decades of the twentieth century.[2] Among those artists whose prints were recognised as a significant part of their artistic oeuvre were Charles Meryon (1821–68), Alphonse Legros (1837–1911), Edouard Manet (1832–83), Edgar Degas (1834–1917), Camille Pissarro (1830–1903) and Henri de Toulouse Lautrec (1864–1901). In Britain the leading advocates included the American-born James Abbott McNeill Whistler (1834–1903) and Francis Seymour Haden (1818–1910).

The Etching Revival was a movement that sought to restore the reputation of intaglio printing as an artistic medium. While the history of printmaking includes the names of Old Masters such as Albrecht Dürer and Rembrandt van Rijn, in truth, the majority of images

1 'Interesting Exhibition by Miss E. Solomons and Miss M. Duncan', *Freeman's Journal*, 28th February 1919.

2 Arthur M. Hind, *A History of Engraving and Etching from the Fifteenth Century to the Year 1914* (1963), 312–340. For more recent contextualisations see Emma Chambers, *An Indolent and Blundering Art; The Etching Revival and the Redefinition of Etching in England 1838–1892* (1999), and Elizabeth Helsinger et al., *The 'Writing' of Modern Life: The Etching Revival in France, Britain, and the U.S., 1850–1940* (2008).

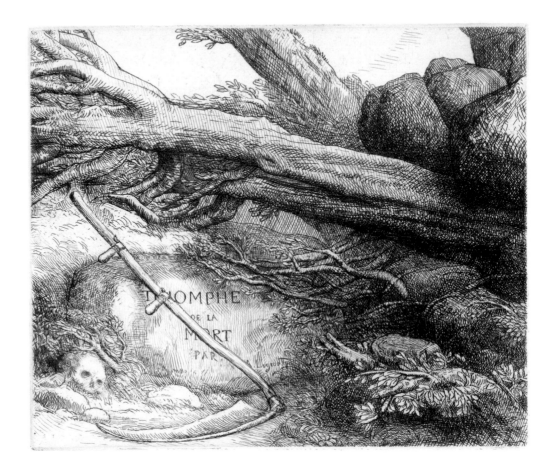

fig.1

Alphonse Legros
(1837–1911)
*Triumph of
Death*, c.1880

NGI 11475

printed historically were reproductive, meaning they were not produced from original designs but rather were facsimiles after other art objects. Print production had become dominated by professional engravers, craftspeople who translated the designs of others to plates or blocks for commercial publishing, either as individual prints or for book illustration. Etching Revivalists encouraged artists, and the art-buying public, to see etching not as a reproductive technique but as a creative medium. The Revival also coincided with the emergence of realist movements in France. Modern artists – abandoning the classicised stylistic conventions of academic practices – worked directly from nature, visualising their physical and subjective experiences of modern life. As argued by Revivalists, this new, spontaneous and interpretative approach to the observed motif, either urban or rural in theme, lent itself well to the medium of etching.

The theoretical writings of Haden and others directed artists to work directly from nature onto the etching plate in order to preserve their immediate responses. Haden described each etched plate as an original artwork.[3]

3 Chambers, 127.

One of the most influential figures in terms of the artist's print was Whistler. Following his studies in France, Whistler recognised the dearth of printing facilities and training in Britain and was instrumental in bringing the French artist and printmaker Alphonse Legros to London (fig.1). By 1875 Legros had become Master of Engraving at the Royal College of Art, South Kensington and from 1876 to 1894 held the Slade Professorship of Art at University College, London. A 1917 publication, *The Graphic Arts of Great Britain*, published by *The Studio*, acknowledged Legros's practical contribution to the development of British printmaking, claiming that he 'brought with him his masterly equipment and … his instructive example proved a fruitful inspiration …'.[4] His method of teaching was through practical demonstration, drawing and painting directly from the subject, as was his practice as an etcher.[5] With Whistler, in deference to the legacy of Rembrandt, and in defiance of professional engraving practices, Legros shared an enmity towards the over-etched plate, preferring to judiciously leave areas with little or no treatment. This form of omission would become a dominant feature of modern etching art practice.

4 Charles Holmes, *The Graphic Arts of Great Britain* (1917), 58.
5 *Six Etchings by Alphonse Legros* (1907).

Among the most influential painter-etchers in England were Whistler, Haden, Walter Sickert (1860–1942) and Legros's students William Strang (1859–1921) and Frank Short (1857–1945), each of whom were known to Irish artists through exhibitions of their work, their writings or as teachers. Irish artists and audiences became familiar with Etching Revival theories and practices which appeared in art periodicals of the day including *The Art Journal*, *The Studio* and *The Magazine of Art*, and specialist print magazines such as *English Etching* (1881–91) and *Portfolio* (1870–93). These publications were available across the British Empire and in time Irish painter-etchers would grace their pages.

Whistler and the beginning of modernist etching in Ireland

On formalist grounds, the single greatest influence on the majority of Irish printmakers was Whistler. His reputation as an etcher in Britain was secured with the publication of his critically acclaimed and commercially successful *Thames Set*, executed during the 1860s, although not published until 1871 (fig.2). Following the example of the French master Charles Meryon, Whistler drew the scenes and characters of London's docks directly from life onto the varnished plate.[6] This Whistlerian practice of engaging directly with nature would inspire an amateur member of a Dublin art society to produce their own series of etchings, marking a beginning, albeit modest, for Irish original printmaking.

6 Chambers, 132.

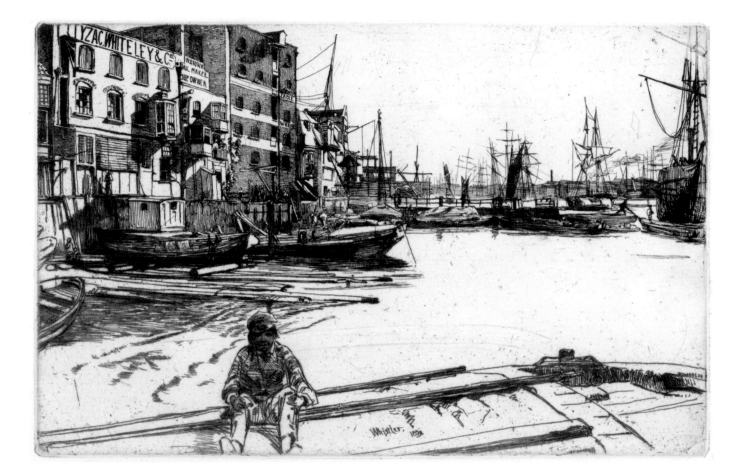

fig. 2

James Abbott McNeill Whistler (1834–1903)
Eagle Wharf, 1859
The Hunterian: University of Glasgow, GLAHA: 46731

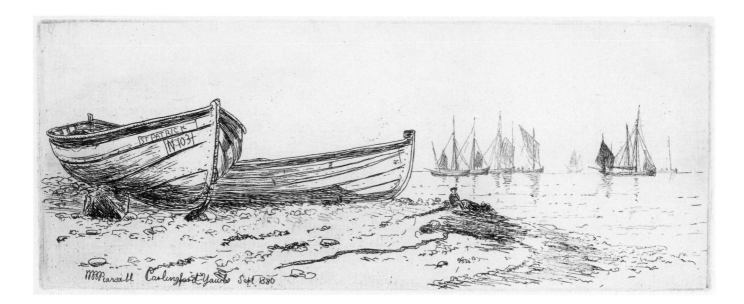

fig.3
William Booth Pearsall (1845–1913)
Carlingford Yawls, 1880
NLI Special Collections, 767 f 1

1880 saw Francis Seymour Haden and his supporters establish in London what became the Royal Society of Painter-Etchers, an organisation that supported and promoted etching as an original artform. That same year William Booth Pearsall (1845–1913), a key committee member of the Dublin Sketching Club (DSC), exhibited a number of limited-edition etchings. Founded in October of 1874, the DSC 'was formed … for the purpose of bringing together artists, amateurs and gentlemen interested in art, in friendly and social intercourse, promoting a taste of fine art in Dublin …'.[7] However by 1884, the club was described by the press as second only to the Royal Hibernian Academy (RHA), in terms of its importance to the visual arts in the city of Dublin.[8] On the instigation of Booth Pearsall, the DSC invited James Abbott McNeill Whistler to exhibit with the club in 1884, affording the citizens of Dublin a rare opportunity to see at first hand the work of an important international contemporary artist.[9] Some years later Hugh Lane, founder of the first municipal modern art gallery in Dublin and the British Isles, would echo Booth Pearsall's actions, arguing that in order for the visual arts to flourish in Ireland artists and the public needed to be exposed to contemporary art from abroad.[10]

Booth Pearsall had been a collector of Whistler's prints and in the early 1880s had begun a personal correspondence with him.[11] Inspired by his mentor, Booth Pearsall and other DSC members, including William Fitzgerald, began to make etchings. Fitzgerald's prints are not modernist and are dominated by fanciful vignettes of caricatures and literary inventions, though some of his prints may represent the docklands of Dublin and its vagrant population. In comparison, Booth Pearsall seeks to emulate Whistler in terms of his marine subject-matter, working directly from the motif and taking a selective approach to the plate. A DSC catalogue entry states that his print *Carlingford Yawls* (fig.3) was 'etched from nature'.[12]

By 1886, Booth Pearsall had founded a new society, the Dublin Art Club (DAS), which was modelled on the New English Art Club by exhibiting the work of young Irish artists alongside that of other contemporary British artists.[13] Over the following years, etchings by Whistler, Meryon, Sickert, Legros, Short and other leading figures of the Etching Revival would grace the walls of the DAS, ensuring that Irish audiences had access to important contemporary etching. Booth Pearsall's fellow committee members and personal friends, the Irish painters Walter Osborne and Joseph Malachy Kavanagh, gained their experience of etching while studying in Antwerp.

Irish artists and etching in Europe

From the second half of the 1800s, a number of Irish painters chose to study beyond Dublin and London. Travelling to the continent, some trained at the Académie Royale in Antwerp under the Belgian Realist painter Charles Verlat (1824–90). Verlat was also a dedicated etcher

7 Dublin Sketching Club, *Catalogue of the first Public Exhibition of Sketches and Studies* (1876).

8 Ronald Anderson, 'Whistler in Dublin', *The Irish Arts Review*, Vol.3, 1986, 45–51.

9 S.B. Kennedy, *Irish Art and Modernism 1880–1950* (1991), 51, fn. no.31.

10 Hugh Lane, 'Preface', *Catalogue of the Exhibition of Works by Irish Painters* (1904), x.

11 The Correspondence of James McNeill Whistler, University of Glasgow https://www.whistler.arts.gla.ac.uk/correspondence/exhibit/result/?exhibid=Dubl-1884&sort=2.

12 Dublin Sketching Club, *Fifth Annual Exhibition of Sketches and Studies* (1880).

13 Julian Campbell, *The Irish Impressionists: Irish Artists in France and Belgium 1850–1914* (1984), 115.

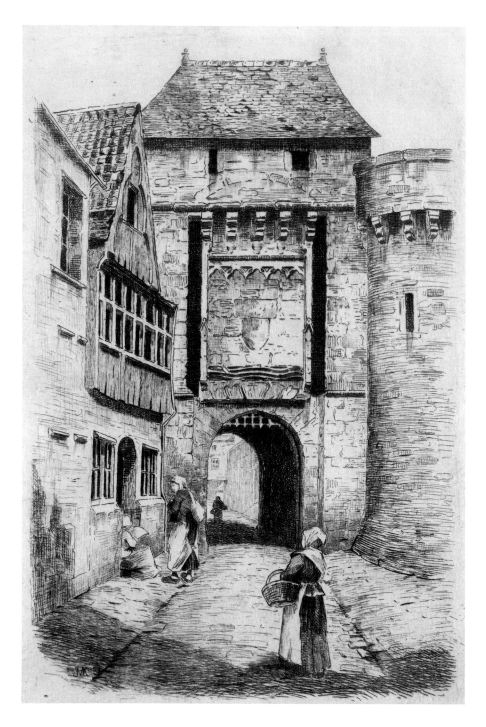

fig. 4

J.M. Kavanagh (1856–1918)
The King's Gate,
Mont St Michel, 1885

14 Campbell, 83.

and required that his students visit the Plantin Moretus Museum of Print in Antwerp, to study, and appreciate, its collection of Old Master prints and plates.[14] Among Verlat's Irish students were Joseph Malachy Kavanagh (1856–1918), Walter Osborne (1859–1903), Roderic O'Conor (1860–1940) and Dermod O'Brien (1865–1945), each of whom would become involved in the production or promotion of prints to some degree in their careers.

Contemporary catalogue entries reveal that Kavanagh produced a substantial body of prints during his career; however, unfortunately, the majority of these have not been located since. Of interest is the fact that Kavanagh's extant early etchings of French and Belgian subject-matter are at a remove from Revivalist principles (fig. 4). In line with academic conventions, they were based on sketches made on site by the artist and worked up in the studio. Therefore, his etchings, comprising finely detailed renderings of light, texture and perspective, lack a sense of spontaneity.

Only two prints have been identified by Walter Osborne; both are etchings which date to 1882, his second year in Antwerp. They seem to have been student exercises, as no other prints have been identified. One is titled *Head of a Terrier*, and the other, *The Flemish Cap* (see page 55), is a portrait study of an old peasant woman in traditional dress. In the same year, Osborne painted the figure wearing a similar head-dress, naming her as *Modenke Verhoft* (see page 54).[15]

15 Jeanne Sheehy, *Walter Osborne* (1974), 112.

Osborne's prints, while interesting in terms of their subject-matter, reveal the artist's limited knowledge or expertise in achieving variations of line quality or tonal values through etching. The plates were not properly cleaned or polished before printing; inked 'scratch' marks make the prints appear dirty. These works were not intended for exhibition, however, and both prints found their way to the collection of the etching enthusiast, and Osborne's friend, William Booth Pearsall. Etched on zinc, the prints were probably shown for the first time publicly in 1983, as part of an Osborne retrospective held at the National Gallery of Ireland.[16]

16 Jeanne Sheehy, *Walter Osborne* (1983), 49.

Another student of Charles Verlat was the Roscommon-born artist Roderic O'Conor. However, despite having opportunity, no prints have been identified by O'Conor from his time in Belgium. O'Conor produced the majority of his prints in the year 1893, under the guidance of the French master-printer Armand Séguin (1869–1903), when both artists worked together in the area of Le Pouldu in north-western France. Using zinc, a common roofing material in the area, and with no access to a fully equipped print studio, although they did have a small printing press, the prints have an experimental quality.[17] The majority of the etchings depict landscapes, with a number of studies of the local Breton population (fig. 5). The influence of Paul Gauguin (1848–1903), the founder of the Post-Impressionist Pont-Aven School and friend of O'Conor, is visible. Through bold, reduced forms and expressive colour (in paint), the group presented imaginative and emotional responses to nature. Not only was O'Conor driven

17 Royal Academy of Arts, *Gauguin and the School of Pont Aven; Prints and Paintings* (1989), 98.

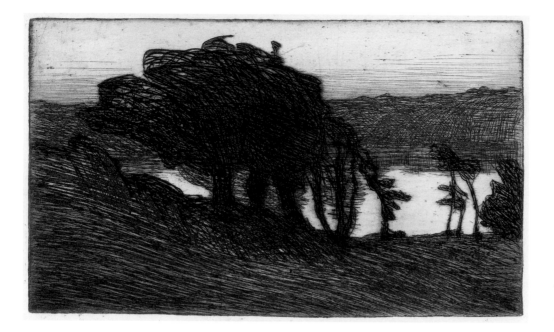

fig.5

Roderic O'Conor
(1860–1940)
*Landscape with Dark
Trees and a River*, 1893

NGI 2009.19

stylistically by Gauguin and his followers, but as a school they were willing to experiment with a variety of media, especially media and techniques which were less well regarded within the fine art hierarchy, including print.[18] O'Conor's etchings possess a sense of uncomplicated directness, and are rich in tonal variation. In this approach, O'Conor was following the example of Gauguin, who called for artworks of simplicity, rather than sophistication, to allow for clarity of expression.[19]

The Irish painter-etcher in London

The eighteenth, nineteenth and early twentieth centuries saw many of Ireland's finest artists and designers travel to London in search of training, recognition and markets for their work, in an effort to establish a foothold in the Empire's political, economic and cultural capital.[20] This close artistic alignment and identification with England by Irish artists became a focus of nationalistic commentary. The writer, social activist and artist George Russell (AE) argued for the recognition of a distinctive school of Irish art – as had been achieved by Irish Literary Revivalists.[21] Russell argued that in order for a distinctive Irish style of art to evolve, it should be exposed to good contemporary art from the continent. By following French modernist practices, that is, working directly from the motif in nature, Irish artists would create realist

18 Ibid., 11.

19 Ibid., 17.

20 For a cultural history of the Irish in London see Fintan Cullen and R.F. Foster, *'Conquering England': Ireland in Victorian London* (2005).

21 *Daily Express*, 10th December 1898.

artworks that were reflective of Irish life and traditions. Cultural networks between London and Ireland were strong and Hugh Lane, an art dealer who depended on these, recognised this. When Lane opened Dublin's Municipal Gallery of Modern Art in 1908 it had many British artworks on display alongside contemporary French examples, including works listed under the 'Etchings and Lithographs' section. The artist-prints shown included examples by Alphonse Legros, William Strang and Whistler. One etching was by the Irish artist, Sarah Cecilia Harrison, a former pupil of Legros. Harrison was Lane's stalwart assistant and it was probably at her instigation that prints were displayed. Echoing the wider agenda of the institution, their presence can be construed as an attempt to stimulate a new Irish school of art that would include printmaking. However, there was already in existence a group of Irish painter-etchers living and working in London.

One of the Irish artists to join the Royal Society of Painter-Etchers was Francis Sylvester Walker (1848–1916), who was made an associate in 1890 and a fellow in 1895.[22] Born in Meath, Walker had studied in the Royal Dublin Society School and in the RHA. By 1869 he was living in London and employed by the Dalziel Brothers as an illustrator, following the example of many other Irish artist expatriates working as commercial illustrators. He was a frequent contributor to *The Graphic* and *The Illustrated London News*.[23] In addition to his work in publishing, Walker also made artist's prints. In 1892, he showed thirteen etchings of English views including *St Paul's Cathedral in Moonlight* (see page 61) at the annual RHA exhibition, which was the most prolific display of original prints by an Irish exhibitor at the RHA at that time or after.[24] However, Walker's style represents a group of painter-etchers whose work was not in accordance with Revivalist theories of subjective selection and interpretation of nature but, rather, it was in keeping with his academic and illustrative training and experience. Walker's prints are concerned with tonality, depth and surface texture, and their heavily worked surfaces often combine a number of intaglio processes including etching, engraving and mezzotint.

The first Irish-born artist to be recognised by the Royal Society of Painter-Etchers was Robert Goff (1837–1922). He was elected a Fellow of the Society in 1887.[25] Goff was not a professional artist but a former British colonel and, like Whistler, he first learned to etch in the army. Retired at the age of forty-one, Goff was a man of independent means which afforded him a great deal of creative freedom. From the 1880s, he produced hundreds of prints, chiefly landscapes, made during his extensive travels throughout Europe, Asia and North Africa. Nearly two hundred and fifty works by Goff, donated by the artist, are held in the Prints and Drawings collection of the British Museum. His prints were well received critically and appeared in periodicals including *The Magazine of Art* and *The Studio*.[26] Goff was an advocate of the Etching Revival. Revivalists were concerned with 'false' etching and 'true' etching;

22 Martin Hopkinson, *No day without a line; The History of the Royal Society of Painter-Printmakers 1880–1999* (1999), 57.

23 Ronald Pickvance, *English Influences of Vincent Van Gogh* (1974), 54, 67.

24 Anne Stewart, *Royal Hibernian Academy of Art Index of Exhibitors 1826–1976, Vol. III* (1986), 237.

25 Hopkinson, 56.

26 Fairchild Gallery, *British Printmakers of the 1890s* (1999); https://www.library.georgetown.edu/exhibition/british-printmakers-1890s.

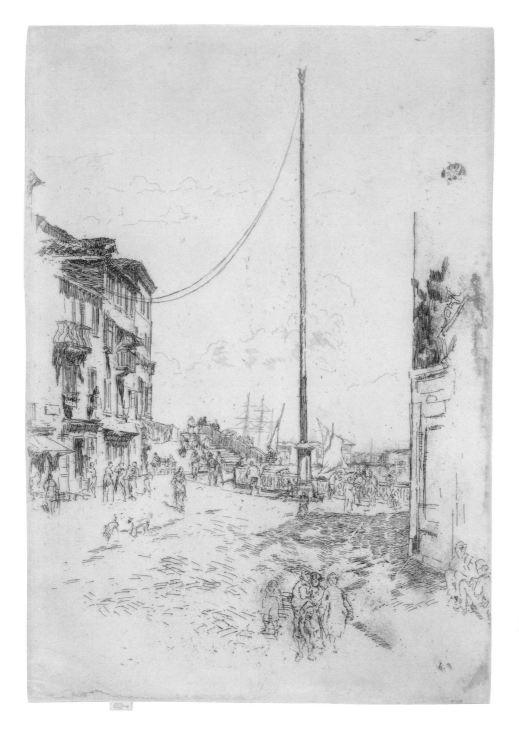

fig. 6

James Abbott McNeill Whistler (1834–1903)
The Little Mast, 1879–80

The Hunterian: University of Glasgow, GLAHA: 46799

27 Richard T. Godfrey, *Printmaking in Britain; A general History from the beginning to the Present day* (1978), 104.

28 Theo Snoddy, *Dictionary of Irish Artists – Twentieth century* (2002), 274.

29 Malcolm C. Salaman, 'The Engraving School at the Royal College of Art', *The Studio*, Vol. 52, May 1911.

30 Ibid.

'false' etching meant attempting to replicate paintings through a high degree of finish as seen in the work of Walker, while 'true' etching comprised of the drawn line, an instinctive process as espoused by Goff.[27] He also practised selective omission, as developed by Whistler in his *Venice Set*, which had become a paragon of modern etching (fig.6).

Wexford-born Myra Kathleen Hughes (1877–1918) lived in London for most of her artistic career. A follower of Revivalist principles, she attended classes in the Slade School of Fine Art in the late 1890s and studied etching with Legros's student, Frank Short (fig.7).[28] Hughes's training under Short concentrated on the mastering of technique.[29] Another important feature of Short's classes was his encouragement of female students to participate in all aspects of the process including its physical challenges: the polishing and preparation of copper and the printing of plates.[30] In 1909, Hughes held a one-person show in London's Dudley Gallery, one of a number of independent galleries that served the growing middle-class market for original

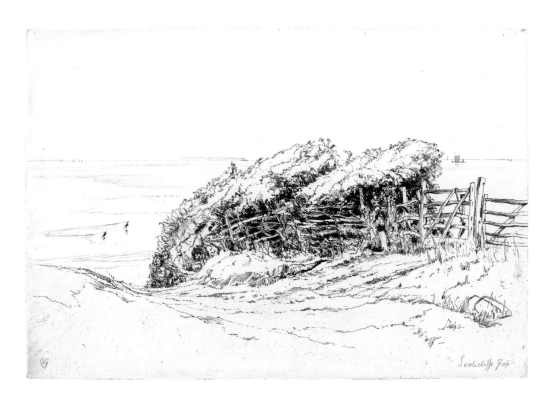

fig.7

Frank Short
Swalecliffe Gap, 1913
The Hunterian: University of Glasgow, GLAHA: 2637

printmaking. The following year Hughes brought the exhibition to Dublin where it was shown at the United Arts Club. In doing so, Hughes was the first artist to have a show devoted solely to modernist prints in Ireland. In the national press, she was described as 'a pioneer' for Irish contemporary etching and 'a revivalist of an art which has long been neglected if not lost'.[31] Hughes was elected an associate of the Royal Society of Painter-Etchers in 1911, one of only thirty-five women at that time.[32] Hughes's prints are interpretative studies of nature and effects of light. Some areas of the plate are richly detailed, while some motifs appear barely visible as sunlight dazzles or bleaches features from view. Her compositions are dominated by architectural subjects, in particular historic areas of London. She also did a number of studies of Dublin which were, unsurprisingly, well received in the Irish media. While domiciled in England, as an acknowledgement of her heritage, many of her prints were signed with a Whistleresque monogram of her initials inscribed in the leaves of a shamrock.

Edward Louis Lawrenson (1868–1940), another former member of the British Army, was born in Dublin and he would gain significant recognition for his experiments in colour intaglio printing. This was a fringe activity among contemporary printmakers, but his contribution to the medium was acknowledged by the award of a gold medal for colour printing at the Milan International Exhibition of 1906.[33] Like Goff, he featured regularly in art periodicals, and was recognised, in particular, for his experimental work in *The Studio*.[34] Lawrenson sought to create repeatable natural tonal and chromatic effects in etching. Traditionally, printers attempted to create identical impressions after each inking. However, Lawrenson's colour prints were more akin to the process of monotype, as each application of ink to the plate was slightly different from the last. While unconventional, Lawrenson's prints are distinguished by their fluid, textural chromatic effects. Despite his critical success, Lawrenson did not become a member of the Royal Society of Painter-Etchers, his exclusion the result of his choice to concentrate solely on colour printmaking. Among the purist members of the Society, there was animosity towards colour, which they argued lacked the authenticity and purity of 'true' etching. Colour prints were not permitted at the Society's exhibitions until 1954.[35] Lawrenson's work features urban and rural scenes from across Europe and a small number of Irish titles. Despite his relative obscurity today, Lawrenson was a well-known figure in cultural circles during the early years of the Irish Free State, his reputation indicated by the showing of six of his colour etchings in a state-sponsored exhibition of Irish art hosted in Brussels in 1930.[36]

Edward Millington Synge (1860–1913) was born in Worcestershire, England into an Irish family. His grandfather had been a Member of Parliament for north Dublin and he was a cousin of the celebrated Irish playwright John Millington Synge.[37] Like Goff, his work was critically well received and appeared in leading art periodicals including *The Art Journal*,

31 *The Daily Express*, 14th December 1910.

32 Hopkinson, 62.

33 Malcolm C. Salaman, 'The Pictures and Prints of Edward L. Laurenson', *The Studio*, June 1911, 220.

34 Holmes, 85, 113.

35 Hopkinson, 38.

36 Musée d'Art Ancien, *Exposition d'Art Irlandais* (1930).

37 Snoddy, 642.

38 Martin Hardie, 'Introductory Note', from James O'Connell and Sons, *Catalogue of a Memorial Exhibition of Original etchings by E.M. Synge, A.R.E.* (1913).

39 *Taisbeantais Oireachtas* (1911).

40 Walter G. Strickland, *A Dictionary of Irish Artists, Vols. I, II* (1913), 421.

41 Martha Tedeschi, 'Whistler and the English Print Market', *Print Quarterly*, XIV, 1997, 15–34.

42 Campbell Dodgson, 'Note on Gethin', from W. M. Crowdy, *Burgundy and Morvan* (1925), unpaginated.

43 Hind, 330.

44 Y.O., *The Irish Statesman*, Vol. 6, 1926, 692.

45 Dodgson, unpaginated.

The Studio and *The Graphic*, and the French periodical *Gazette des Beaux Arts*.[38] He also exhibited regularly at the RHA, and in 1911 eight of Synge's etchings were shown at the Oireachtas Art Exhibition.[39] The Oireachtas was an organisation founded to promote Irish culture and language, and Dermod O'Brien was on the selection committee. Dominated by continental landscapes, notable features of Synge's work are the range of mark-making found in his prints, his interpretative treatment of his subject-matter and his precise manner of inking his plates. Synge was among a small group of etchers to print his own etchings, as the majority of artists worked with professional printers.[40] It had been essential for Lawrenson as a colour etcher to ink and print his own plates; however, Synge's approach demonstrated his creative concerns with the etching process. Fredrick Goulding, a professional printer who had worked with the most celebrated etchers of the day including Whistler, described the approach of artists to printing: 'I think no printer, be he as good a craftsman as may be, could print an etcher's etching the same as he can do it himself … [the artist] may not "pull" two proofs alike, but in each and every one he will have his own art trickling down his arm to his fingers' ends … in each proof there will be an individuality no craftsman could exactly imitate.'[41]

Like Goff, Synge and Lawrenson, Percy Gethin (1874–1916) established his reputation as an etcher of European views; however, he also produced a unique suite of rural Irish-themed prints (fig. 8). Gethin's Irish etchings are a reflection of his close association with key figures in the Irish cultural revival. Gethin was born in Sligo to a wealthy family, his father being a captain in the British Army.[42] He was a regular visitor to the Gore-Booth estate of Lissadell, home of the artist and Republican Constance Gore-Booth Markievicz. He was also part of Lady Gregory's social set, which included Hugh Lane, George Russell (AE) and the Yeats family. Gethin exhibited with Russell and Markievicz in a series of Dublin exhibitions in the 1910s. One of the most influential figures for Gethin as a printmaker was Fred V. Burridge, a former student of Frank Short, who went on to teach engraving in Liverpool City School of Art and at the School of Arts and Crafts in London.[43] Burridge recognised Gethin's potential as an etcher, in that his skills as a draughtsman resulted in a subtle and instinctual approach to the medium. However, Gethin did not exhibit his prints regularly and he was inconsistent in the production of editions from his plates. Gethin's work gained greater recognition following his tragic death at the Front in 1916. Burridge oversaw a posthumous issuing of an editioned series of Gethin's etchings and a set was acquired and exhibited by the British Museum's Keeper of Prints and Drawings, Campbell Dodgson, in 1926. In a review of his friend's work George Russell described Gethin as 'an artist of delicate perception and sure execution'.[44] Dodgson prophetically said of his etchings: 'even if they can never become widely known' through them Gethin had secured his place among 'the best of Irish Artists'.[45]

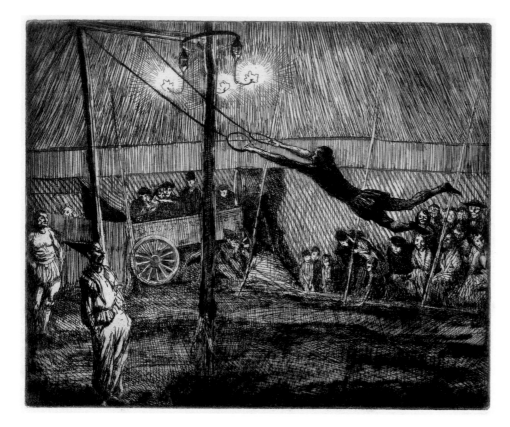

fig. 8

Percy F. Gethin
(1874–1916)
*Travelling Circus,
County Clare*, 1912–13

NGI 11619, presented, Fred
Burridge through Sarah Purser,
1926

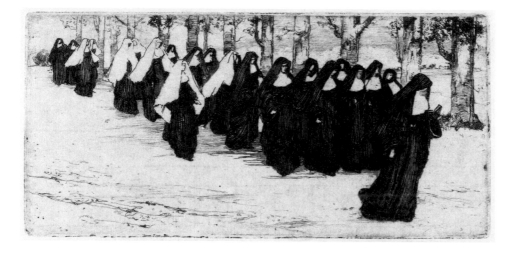

fig. 9

George Atkinson
(1880–1941)
The Nun's Garden, c. 1910

Hugh Lane Gallery, Reg. No. 414

A 'School' of etching in Dublin

Until the 1910s, fine art printmaking was not taught in Irish art schools. England on the other hand, with the arrival of Legros in the 1860s, had ensured the training of generations of etchers. These students became masters themselves and taught subsequent generations, including Irish artists. The dearth of training in printmaking in Ireland was recognised by Verlat's student Dermod O'Brien and, while not a printmaker himself, he had the ambition to see a school of Irish printmaking established. In 1910, while President of the RHA, O'Brien organised a print exhibition to encourage public interest, and it was the largest historical survey of printmaking ever seen in the British Isles. In addition, during the exhibition he invited leading figures in a variety of print disciplines to lecture and give demonstrations; Lawrenson spoke on colour printing and O'Brien's friend William Strang demonstrated etching and drypoint. The event set out to create an appreciation for the artist's print among Irish artists and the public. Another significant development at this time was the appointment of Cork-born George Atkinson (1880–1941), an experienced printmaker, to the teaching staff of the Metropolitan School of Art in Dublin.[46] Atkinson, who had been taught etching by Frank Short in London, was elected an associate to the RHA as an engraver.[47] Atkinson is best remembered for his considerable public role in promoting Irish art and design before and during the first decades of the Irish Free State. While civic duty and administration eventually overtook his own art production, his etchings demonstrate considerable skills and artistry, a strong graphic sensibility and mastery of dynamic compositions (fig. 9). From these developments, the mid-1910s marks the first time 'homegrown' original etchings began to make an appearance in art exhibitions in Dublin.

The most prolific and best-known modernist etcher in Irish art is Estella Solomons (1882–1968). Over a period of approximately twenty years she produced nearly ninety etchings along with a small number of lithographs and woodcuts. Her biographers have attempted to explain where her interest in printmaking originated, pointing to a 1906 trip to Amsterdam where she attended the Rembrandt Tercentenary Exhibition and saw an extensive collection of the master's etchings.[48] Additionally, Solomons studied in London from 1907 where she would have had the opportunity to learn printmaking techniques, although no prints by her date from this period.

Solomons attended Dermod O'Brien's 1910 RHA print exhibition and associated demonstrations, participating in William Strang's etching class. She would not have had much experience in printmaking at that point, therefore she must have taken further instruction in etching. As Atkinson was the only teacher of etching and engraving in Dublin from 1914, it is highly likely that Solomons, and others such as Mary Duncan, went to him for private lessons. His instruction, along with access to college printmaking facilities, allowed Solomons

46 John Turpin, 'The Metropolitan School of Art, 1900–1923, Part II', *Dublin Historical Record*, XXXVIII, 1985, 42–52, 49.

47 Ibid.

48 Hilary Pyle, *Estella F. Solomons, Portraits and Patriots* (1966), 14.

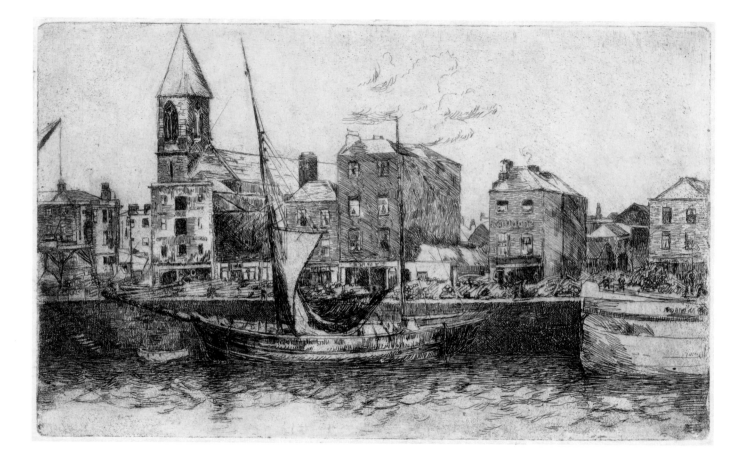

fig. 10

Estella Solomons (1882–1968)
City Quay, Dublin
TCD MS 11583/2018/13

49 TCD, O'Sullivan/Solomons Archive Ms. 4632–511 and Ms. 4644–3453.

and other artists to begin making prints from 1915. Later, Solomons would purchase her own printing press, the first artist in Ireland to do so, which she bought in England some time shortly before 1920.[49]

Solomons's entire etching oeuvre is made up of Irish subject-matter, primarily atmospheric images of inner-city Dublin and working-class life, reminiscent of Whistler's early work (fig. 10). However, she also had an important influence closer to home in Myra Hughes. Hughes had exhibited her etched urban studies in 1910 in Dublin, shortly after O'Brien's RHA Print exhibition and it is more than likely Solomons visited her exhibition. Furthermore, as Hughes's exhibition was solely devoted to prints, it would have left a lasting impression on the younger artist and inspired her to do likewise in the years to come. Throughout the 1920s, Solomons exhibited etchings in solo and group shows which were consistently well received critically. Her private print studio also facilitated her friends, including Mary Duncan and Frida Perrott, to make and exhibit prints. Some forty years after the beginning of the Etching Revival, Ireland had a small but dedicated school of original printmaking.

The international market for artist's prints dissipated with the economic crash of 1929 and few artists continued to make etchings on the scale of previous generations. Not immune to international developments, the modest, but artistically impactive, strides made in printmaking in Ireland had fallen away by the early 1930s. It was not until the foundation of Graphic Studio Dublin in 1960 that Irish artists began to re-engage with etching, marking a new beginning in printmaking which continues to thrive today.

Angela Griffith, Trinity College Dublin

GEORGE ATKINSON (1880–1941)

Shannon Scheme No.2: The Culvert, 1929
Etching, 35 × 41.5 cm
Crawford Art Gallery, CAG.3026

In 1930, George Atkinson exhibited at the Aonach Tailteann art exhibition a series of etched studies based on the Shannon Scheme excavations, at Ardnacrusha, in County Limerick.[1] The collection was a result of a commission from the Free State government, awarded to Atkinson following the recommendation of art adviser Thomas Bodkin, to create a pictorial record of this State-sponsored project. A set of the etchings is held in the Crawford Art Gallery in Cork.

 The dramatic composition of *Shannon Scheme No.2: The Culvert* immediately imparts the scale of works undertaken. A massive concrete pipe cuts through the image at an angle, dwarfing the workers behind. The strain of their efforts is reflected in the tumultuous, textured background, punctuated with the keenly observed structures and tools of industry. The image is a masterclass in draughtsmanship and the art of the etcher's needle.

 Shannon Scheme No.1: Keeper Mountain is an equally striking image and the artist has captured the drama and aggression of man's commandeering of the landscape. To the right of the composition is the River Shannon, Ireland's longest river, curtailed by the piled earth.

 The etchings, like Sean Keating's paintings of the construction of the hydro-electric station, were emblematic of the new direction and progress of the Irish Free State. Atkinson's work testifies to the State's ability to control and use the landscape to serve the nation's needs. As the government sought to affirm the country's sovereignty, that landscape became a vehicle for expressing national identity and its progression. To this end, the prints were also exhibited at an exhibition of Irish Art held at the Musée d'Art Ancien in Brussels in 1930.[2]

1 Sorcha O'Brien, *Powering the Nation: Images of the Shannon Scheme and Electricity in Ireland* (Dublin, 2017).

2 Musée d'Art Ancien, *Exposition d'Art Irlandais* (Brussels, 1930).

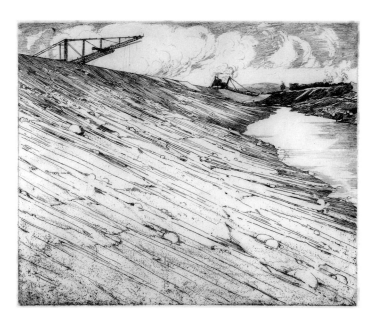

Shannon Scheme No.1: Keeper Mountain, 1929
Etching, 35 × 41.5 cm
Crawford Art Gallery, CAG.277

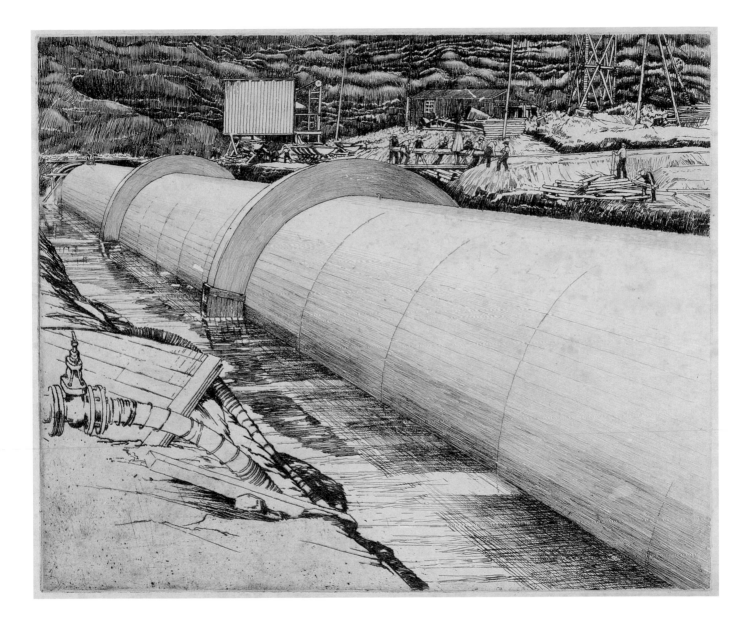

WILLIAM BOOTH PEARSALL (1845–1913)

Sir John Rogerson's Quay, c. 1880
Etching, 22.6 × 28.8 cm
National Library of Ireland, Special Collections, 767 f 1

William Booth Pearsall's depiction of Dublin's industrial docklands demonstrates the influence of his friend, James Abbott McNeill Whistler and echoes the master's celebrated *Thames Set* published nearly ten years earlier. Booth Pearsall, a keen amateur artist, was a founding member of the Dublin Sketching Club (DSC), which encouraged its members to draw and paint *en plein air*.[1] As extolled by Etching Revivalists, Whistler drew directly from life onto the varnished plate, and Booth Pearsall did the same as indicated by an 1880 DSC catalogue entry.[2]

Selected elements of this quayside subject-matter are deftly executed in a bold graphic style which is a feature of the *Thames Set*. But while many of Whistler's prints include figures, Booth Pearsall's figures are incidental or nondescript, an indication of his lack of formal artistic training.

Sir John Rogerson's Quay is one of Booth Pearsall's most successful prints. The composition is taken from a low vantage-point looking inland from the mouth of the Liffey. To the left of the image, the pier extends dramatically into the composition, perpendicular to the picture plane. Booth Pearsall draws the viewer into the scene by choosing to work up the bow of the nearest boat in the foreground while creating almost flat or silhouetted Japanese-inspired forms to represent a quayside crane and mound of coal. The effect sets the finely sketched, unfinished details of the remaining boats and city buildings deep into the distance, underlining the authenticity of the viewpoint. Booth Pearsall's restrained, subjective use of mark-making, in the sky, water and background detail, gives the scene an atmospheric, water-saturated quality. The etching appears in a limited-edition book (only 25 copies were printed), *Eighteen Facts and Fancies in Needlework* (1880), along with 17 other plates.

1 Dublin Sketching Club, *Annual Exhibition of Sketches and Studies* (1886).

2 Emma Chambers, *An Indolent and Blundering Art; The Etching Revival and the Redefinition of Etching in England 1838–1892* (1999), 132.

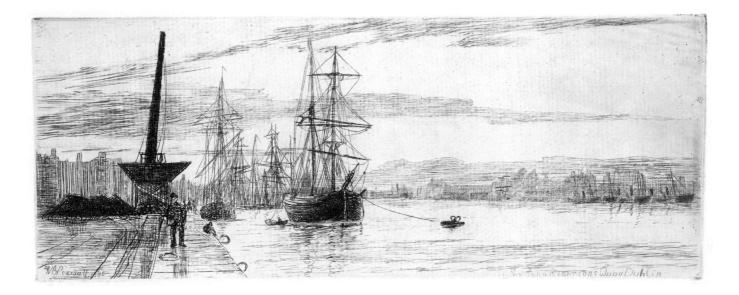

W.B.Pearsall 1880 Sir John Robertsons Quay Dublin

WILLIAM FITZGERALD (dates unknown)

Mendicant Tinker, c. 1880

Etching, 22.5 × 20 cm

NGI 20785, presented, William Booth Pearsall, 1902

William Fitzgerald was a fellow amateur member of the Dublin Sketching Club with William Booth Pearsall. However, unlike Booth Pearsall who was an ardent supporter of Etching Revivalist principles, Fitzgerald had an illustrative approach to printmaking. Many of his etchings are made up of imaginative figures placed in theatrical settings. Images such as these were a product of the Club's 'working meetings' and were called 'subject illustrations', where members were given titles and asked to create an imaginative image relating to the theme.[1]

Fitzgerald has a fluid and confident style of drawing and his characters are expressive. In terms of etching technique, his approach is linear, the form of his subjects is defined through a series of sketch marks. Tone is created through heavy hatching, but the line quality of the key compositional elements, in terms of width and depth, varies little within each print. Light and shade is often inconsistent, and appears unnatural. Depth within the work is suggested by finer lines used to describe the background details. These techniques, along with the overdrawn corrections and stylised treatment of his themes, reveal that Fitzgerald worked directly from his imagination onto the plate.

However, two of Fitzgerald's prints held in the NGI collection, *Mendicant Tinker* and *Low Water*, are subjects more in keeping with European modernist printmaking. The ragged details and expressive qualities of Fitzgerald's *Mendicant Tinker* etching are suggestive of French Realism and pay homage to Rembrandt's etchings of mendicants.[2]

1 Dublin Sketching Club, *Annual Exhibition of Sketches and Studies* (1886).

2 These titles are taken from William Booth Pearsall and William Fitzgerald, *Eighteen Facts and Fancies in Needlework* (Dublin, 1880).

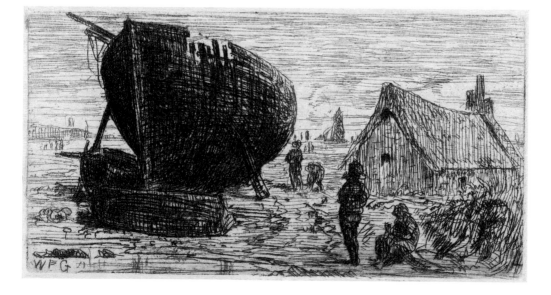

Low Water, 1885

Etching, 14 × 23 cm

NGI 20786, presented, William Booth Pearsall, 1902

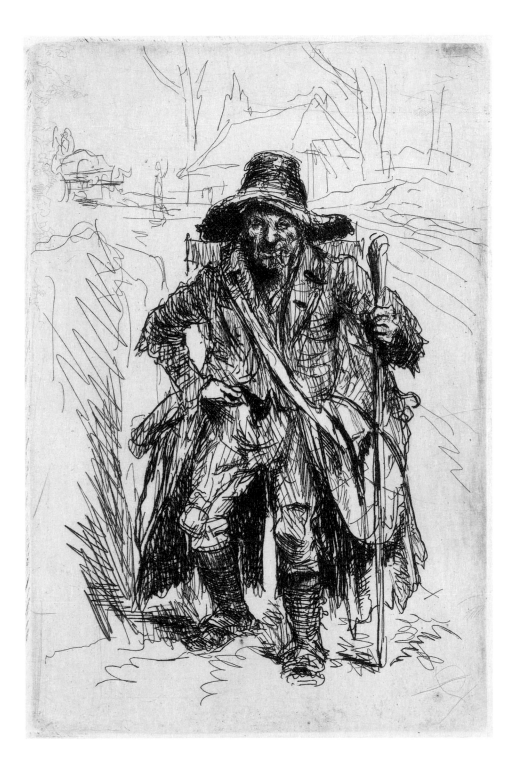

PERCY F. GETHIN (1874–1916)

Peat Bog, 1912–13
Drypoint, 21.5 × 25 cm
NGI 11480, presented, Fred Burridge through Sarah Purser, 1926

This striking etching is one of a number of images of Irish subjects that Gethin made around 1912. Numbered 33/40 and inscribed with title, artist's name and the word 'excrs', it is part of the edition of 40 printed, annotated and published in 1926 by Gethin's executor F.V. Burridge. Fred Burridge, a close friend of Gethin's and Principal of the Central School of Arts and Crafts in London, presented a number of prints to the British Museum and the National Gallery of Ireland. The low horizon line and scratchy drypoint marks of this print are reminiscent of Rembrandt's landscape etchings, particularly *The Goldweigher's Field* of 1651. Gethin's etching may depict the north Mayo coast as it is similar in composition to a watercolour entitled *The Bogs of Portacloy*.[1] Different weights of line are used to describe cuttings in the bog and grass on the surface. Turf piled on a dark bank, a loaded donkey and a farmhouse on the horizon are captured through heavier cross-hatching.

Although born in Holywell House on the shores of Lough Gill in Sligo, Gethin spent most of his life in England. He was educated at Rossall, a public school in Lancashire, and studied briefly at the Royal College of Art in London. He worked as a teacher of 'life and composition' with Burridge, first in Liverpool City School of Art and later at the Central School of Arts and Crafts in London. He began etching while in Liverpool but generally pulled only a few proofs of each plate. *Bending the Jib* is a rare etching (see page 6). An exciting composition, it shows four sailors furling a ship's sail in Liverpool's docks.

In late 1912 Gethin was introduced to the London art dealers Colnaghi and Olbach who editioned and exhibited his work. Harold Wright, their print specialist, collected many of Gethin's etchings which are now in the British Museum's collection. Gethin was killed in action at the Somme in June 1916.

1 The watercolour is illustrated in *Artists' Rifles Journal*, Vol. 1, no. 2, Sept–Oct 1916, 34.

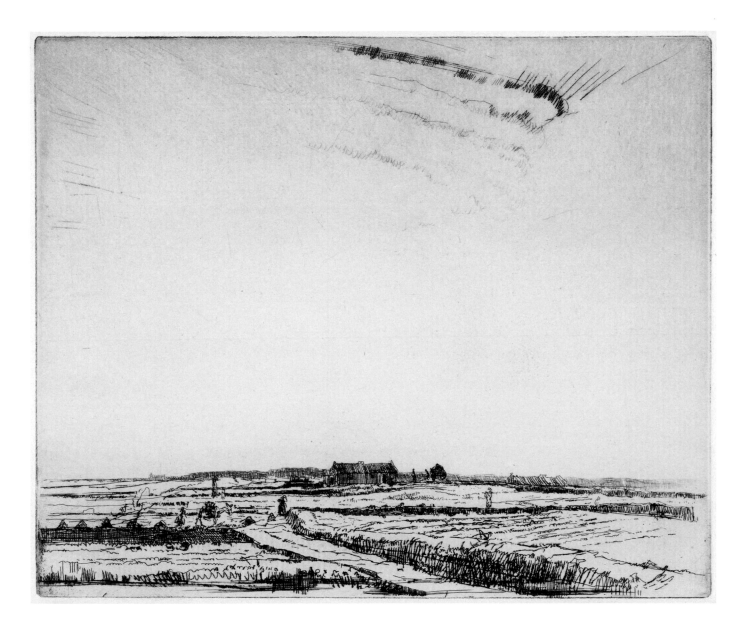

ROBERT C. GOFF (1837–1922)

Shipbuilding, Viareggio, Tuscany, c.1904
Etching, 19 × 23.5 cm
NGI 2011.8, purchased, 2011

Of Irish parentage, Robert Goff received a commission from the British Army aged eighteen and fought in the Crimea. On his retirement from the Coldstream Guards in 1878 with the rank of colonel, he devoted his time to travel and art. Self-taught, he nonetheless became a widely respected printmaker specialising in topographical etchings and was elected a Fellow of the Royal Society of Painter-Etchers and Engravers in 1887.

Goff was inspired by the work of Whistler, and his 1905 etching *Tower Bridge* is often cited as a work directly influenced by Whistler's ideas: '… [his] almost calligraphic economy of statement caused etchers to explore different avenues of expression. This is clearly seen in *The Tower Bridge*, where Goff delineates the manner in which the eye focuses on either the foreground or the background'.[1]

Similarly, in the undated Venetian etching in the NGI collection, *Doge's Palace, Venice*, the foreground and the buildings in the distance are cursorily drawn while the mid-ground buildings are fully worked up. The second print by Goff in the NGI collection, *Shipbuilding, Viareggio, Tuscany*, is an excellent example of Goff's skill as an etcher. There is incredible detail in the scene: the strangely skeletal half-built ships dominate but myriad figures, men sawing huge logs and securing planks and curious children looking on, add life and energy. The plate is richly etched with subtle plate-tone and probably dates to 1904 when Goff spent time in Tuscany.

In 1899, 1911 and 1922 Goff presented sets of his landscape etchings (made between 1883 and 1911) to the British Museum, 239 in total. Although he exhibited six works at the RHA exhibition of 1883, and loaned an etching *Musky Cairo* to the Irish International Exhibition in 1907, he does not seem to have regarded himself as an Irish artist. Unlike other notable painter-etchers, including Francis Walker and Myra K. Hughes, Goff was not listed in the Irish section of the exhibition but appeared with the British artists.[2]

1 Kenneth M. Guichard, *British Etchers: 1850–1940* (1981), 39.

2 William F. Dennehy, *Record: The Irish International Exhibition* (Dublin, 1909), cxii.

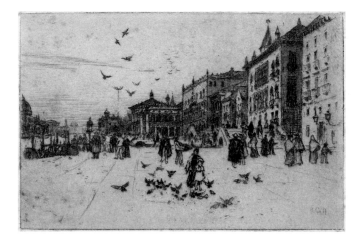

Doge's Palace, Venice, c.1903
Etching, 14.1 × 19.8 cm
NGI 11871, provenance unknown

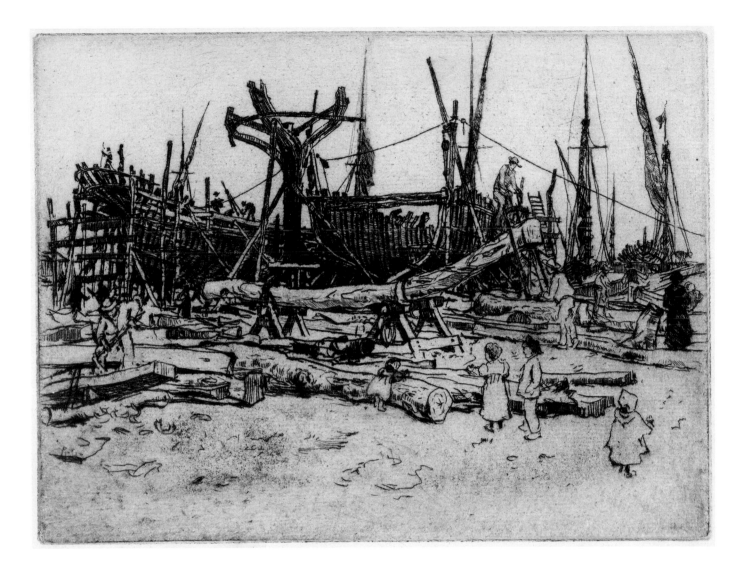

SARAH CECILIA HARRISON (1863–1941)

Study of a Man's Head, c. 1880

Etching, 20 × 15 cm

Hugh Lane Gallery, Reg. No. 430

Born in County Down, Sarah Cecilia Harrison was a celebrated portrait artist in Dublin at the turn of the last century. She is also remembered today for her contribution to Ireland's political and cultural life. Harrison played a key role in the establishment of the Municipal Gallery of Modern Art in Dublin in 1908 and was a steadfast supporter of Hugh Lane and his aims to create a vibrant contemporary art scene in Ireland. She assisted Lane in the curation of the space in a house on Harcourt Street, and she compiled the gallery's illustrated catalogue. In 1912, Harrison was the first woman to be elected a Dublin Corporation councillor.

Like many of her Irish peers, Harrison trained abroad and was a student of Alphonse Legros at the Slade School of Art in the 1880s. She was introduced to the process of etching as part of her studies and received a number of awards and commendations for her print work.[1] Her keenly observed *Study of a Man's Head*, the only example of a print by Harrison in a public collection, demonstrates the influence of Legros. While many Etching Revivalists looked to urban and rural themes, Legros, betraying his academic background, gained a reputation for painted and etched portraits of his London contemporaries. Many of Legros's students, including William Strang, produced portraits in print. This print may have been a student exercise undertaken with Legros, in the same way that Walter Osborne's etchings were made while he was a student in Antwerp under Charles Verlat.

Harrison was behind the display of contemporary prints in Hugh Lane's influential 1908 exhibition. The catalogue reveals that she donated *Study of a Man's Head* to the gallery, which made her the only Irish exhibitor of print. She also donated a number of etchings by William Strang to that show, indicating that she was a collector of prints.

1 Hannah Baker, *Sarah Cecilia Harrison: A Reassessment of the Artist*, M.Phil. dissertation (TCD) (2017), 13–14, unpublished.

MYRA HUGHES (1877–1918)

Sackville Street, c. 1910
Etching, 15.9 × 16.2 cm
The British Museum, PD 1919,0528.8, given by the family of the late Myra Hughes through Mary C. Hamilton

The largest public collection of Hughes's prints is to be found in the British Museum.[1] A student of Frank Short, Hughes established a considerable reputation in England as an original printmaker, exhibiting her work in London, Liverpool and Dublin. She also featured in the pages of *The Studio* art periodical. She grew up in Rosslare, County Wexford and attended Westminster School of Art and the Royal College of Art.

1 https://www.britishmuseum.
org/research/collection_
online/search.aspx?search
Text=Myra+K+Hughes.

An ardent disciple of the Etching Revival, her works reveal a discerning approach to the plate. One of her few Irish-themed etchings is *Sackville Street*, the principal thoroughfare of Ireland's capital, renamed O'Connell Street after the establishment of the Irish Free State in 1924. This etching may have been included in Hughes's 1910 exhibition at Dublin's United Arts Club. The image displays her selective and subjective treatment of her subject-matter. The immediate foreground is occupied by the finely outlined figure of a young newsboy while receding buildings, which were destroyed during the Easter Rising of 1916, are carefully described. Another Dublin centre landmark since vanished, Nelson's Column, looms as a shadow. Hughes idiosyncratically chooses to detail emphatically – in dense drypoint – the nationalist monument to Daniel O'Connell, with Dublin's city life thronging below.

Another, more restrained print is a seascape entitled *On the Way to Holy Island*. The exact location of the scene is unknown, but the flat surroundings and the title 'Holy Island' may refer to an area known locally as 'Lady's Island', a pilgrimage site dedicated to the Virgin Mary near Carne in County Wexford, the artist's home county, or it may be a depiction of the Holy Island of Lindisfarne off the north-east coast of England. While Hughes's work as printmaker was recognised early on, both in England and to a lesser extent in Ireland, her influence was perhaps not as wide-ranging as it may have been, due to her death at the young age of forty, in 1918.

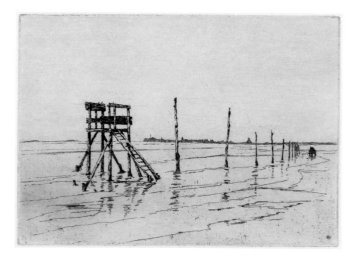

On the Way to Holy Island
Etching, 12 × 17 cm
The British Museum, PD 1919,0528.6

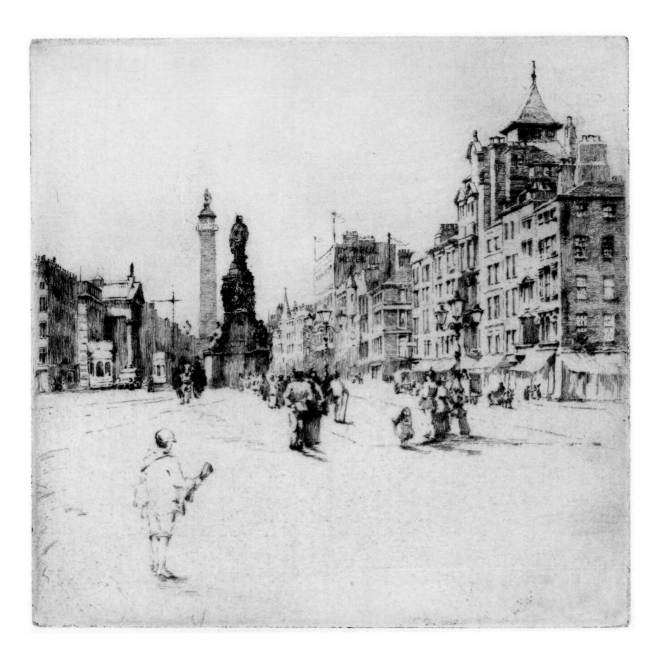

JOSEPH MALACHY KAVANAGH (1856–1918)

Palingbrug, Antwerp, 1883
Etching and drypoint, 19.5 × 13.5 cm
NGI 20861, bequeathed, Mrs K. Baskerville, the artist's grand-niece, 1997

It was while studying under Charles Verlat at the Académie des Beaux Arts in Antwerp that Dublin artist Joseph Malachy Kavanagh took up the art of etching. Kavanagh had travelled to Antwerp in 1881 with Walter Osborne and Nathaniel Hill, where they took classes in 'nature' and 'still-life' with the influential Belgian teacher. Of the three, Kavanagh was most interested in printmaking. He exhibited etchings along with paintings at the Royal Hibernian Academy's annual exhibitions of 1883, 1884, 1885 and 1886; six in total, mainly of Belgian and French scenes, each priced at £1.1s. In 1890 the Dublin Art Club issued a portfolio of nine etchings, examples of current practice in Ireland. Five of these prints were by Kavanagh, including *On the Ramparts, Mont St Michel*. It appears Kavanagh regarded *The Metallurgist*, first exhibited at the RHA in 1886, as particularly successful. He exhibited it again in 1889 at the Dublin Art Club exhibition (for the higher price of £5) and a third time at the RHA's 1910 show.

Although his subject-matter and technique are conventional, Kavanagh's etchings display a good understanding of that technique. *Palingbrug* depicts a quiet street in the old quarter of Antwerp. Light and shade are created through the use of hatching, polishing back and plate-wiping. Two female figures add movement and energy to the scene. In terms of subject-matter and technique it calls to mind the work of Mortimer Menpes, a major figure in the Etching Revival. *On the Ramparts* incorporates elements that also appear in his paintings: the figure with satchel can be seen in *The Old Convent Gate, Dinan*, NGI 1194. Despite Kavanagh's early enthusiasm for etching, he is not known to have made any prints after 1886 and is best known as a painter and administrator, being Keeper of the RHA between 1910 and 1916.

*On the Ramparts,
Mont St Michel*, 1885
Etching and drypoint,
21.5 × 13.5 cm
NGI 20862, bequeathed, 1997

JOHN LAVERY (1856–1941)

Two Figures in a Boat, 1883
Etching, 28.7 × 14.9 cm
NGI 2017.49, purchased, 2017

This rare etching is accompanied by a note written by Lavery in 1940 stating that it is 'the only etching I have ever done. The copper plate was destroyed when my studio and all its contents were burnt in Glasgow about 1883. I cannot remember, but I think there was more than one proof in existence when the plate perished.'[1]

Although quite tentative in terms of technique, the composition is well realised and the print is signed and dated prominently in the plate. It shows the painter experimenting with an unfamiliar technique, using line to create reflections and a sense of light and shadow. It is close compositionally to his painting *Return from Market* (NGI 2011.11), although in the painting the figure in the back of the punt is an old woman rather than a man. The body of the young girl manoeuvring the boat to shore is more static in the print.

In 1881 and 1882 Lavery attended classes at the famous Académie Julian in Paris. Lavery failed to meet the standards of his teacher William-Adolphe Bouguereau and remembered later: 'I had yet to understand what drawing really meant.'[2] In 1883 and 1884 he spent time in the artists' colony of Grez-sur-Loing. This ancient river village, about 80 km south of Paris, was inspirational for him. He produced an impressive body of work in Grez, based on *plein-air* study, which gives a comprehensive record of life there in the early 1880s. Lavery depicted both the local people and his fellow artists. This etching may have been worked up from a sketch or the plate may have been etched out-of-doors. Close examination of the surface of the painting reveals that Lavery reworked the girl to give her a more central position, and this print could represent another stage in the development of the composition. It is likely Lavery made this print with help from an artist confident in the etching technique. It is tempting to suggest that his close friend Whistler advised him, but the two men did not meet until 1887.

1 Documentation in dossier file, NGI 2017.49, Prints and Drawings Study Room.

2 Kenneth McConkey, *John Lavery a Painter and his World* (2010), 16.

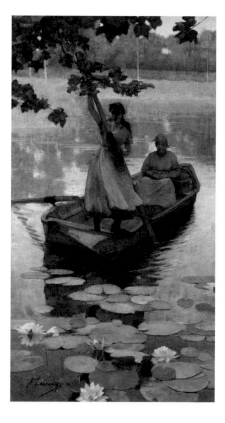

Return from Market, 1883
Oil on canvas, 21.1 × 13.3 cm
NGI 2011.11

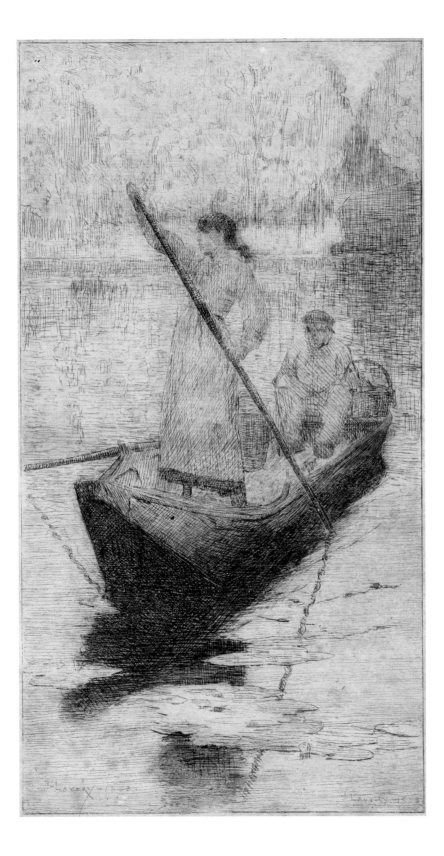

EDWARD L. LAWRENSON (1868–1940)

Sognefjord, 1924
Colour aquatint and soft ground etching, 30.3 × 40.2 cm
The British Museum, PD 1924,1112.7

In 1911, *The Studio* critic and print enthusiast Malcolm Salaman wrote an article on Lawrenson describing him as primarily a landscape painter who chose to focus on printmaking as his creative method.[1] Like Gethin, Goff, Hughes and Synge and other modernist etchers, Lawrenson was part of the *plein-air* school of printmaking and had a novel method of working. As recorded by Salaman, while having a studio in London his 'more work-a-day studio is his motor car'. This set-up allowed the artist to work directly from the motif before him. As a painter-etcher who worked in colour, Lawrenson's choice of subject, dominated by landscapes and cityscapes, was 'determined chiefly by the opportunities it offers as a colourist'. In terms of printmaking, Lawrenson was self-taught. Although he attended lectures given by Frank Short on etching and aquatint, he undertook his own experiments in colour printing – a practice not supported by Etching Revivalists in the main.

1 Malcolm C. Salaman, 'The Pictures and Prints of Edward L. Laurenson', *The Studio*, June 1911, 216–223.

The spectacular site of Sognefjord, Norway's deepest fjord, had attracted artists since the nineteenth century. Lawrenson captures the towering majesty of its mountains, emphasised through his use of a deep blue for the dominating stone face, set against small areas of pale, mottled sky and dappled water. A village on the lower left is dwarfed by its surroundings, a Turneresque touch. The print was made using three different plates, one for each colour: blue, grey and orange. The British Museum holds a number of trial proofs, many with hand-written notes by the artist in the margins.[2]

A rare Irish subject in Lawrenson's oeuvre, the interior scene *The Dublin Bottlemakers*, evokes the heat, murky light and energy of a busy glass workshop in Ringsend.

2 https://www.britishmuseum.org/research/collection_online/search.aspx?people=117856&peoA=117856-2-60.

The Dublin Bottlemakers, 1903
Colour aquatint and etching, 22.6 × 30.4 cm
The British Museum, PD 1924,1202.5

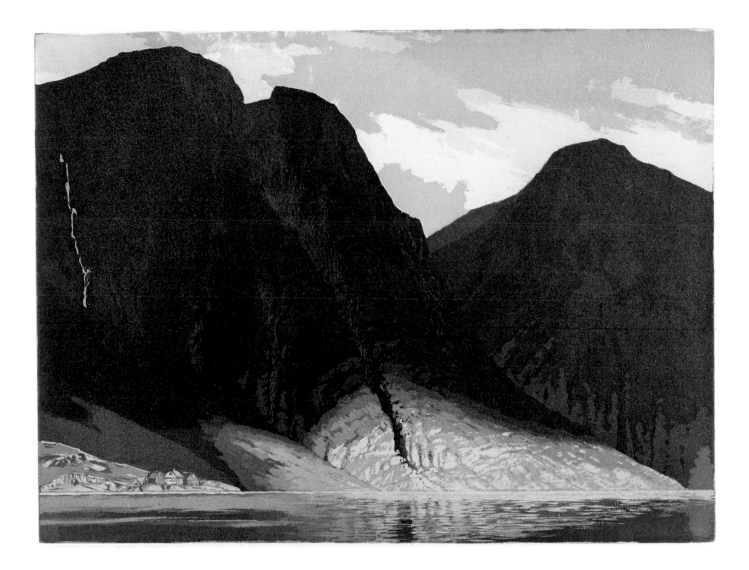

RODERIC O'CONOR (1860–1940)

Coastal Landscape, 1893
Etching and drypoint with roulette, 20 × 28.6 cm

NGI 2009.20, purchased, 2009

Roscommon-born Roderic O'Conor studied art in Dublin, Antwerp and Paris. In 1891 he went to Brittany where he worked closely with a group of artists led by Paul Gauguin. In 1893 O'Conor stayed with the Breton printmaker Armand Séguin (1869–1903), whom he had met in Paris. Together they made a series of prints in and around Le Pouldu, a windswept, isolated hamlet to the east of the established artists' colony of Pont-Aven. O'Conor, although a confident and established painter, was a complete novice in terms of printmaking. Séguin taught the older artist how to etch and O'Conor's bolder drawing style influenced Séguin's work. Forty-three prints by O'Conor have been identified, 35 of which are etchings, and 17 of these can be linked to Le Pouldu.[1]

This etching resembles a page from a sketchbook and it is likely O'Conor brought prepared sheets of roofing zinc into the wild coastal landscape, drawing directly from nature onto the makeshift plates. The multiple small scratches and imperfections and the lack of the fine finish characteristic of professionally printed works indicate that they were probably printed on a small proofing press.[2] Because of their experimental nature, only a small number of proofs were pulled, and O'Conor never editioned any of his prints.

He explored the technique of etching thoroughly, using rhythmic lines similar to those in his characteristic striped paintings. He worked spontaneously, the strong, directional etched lines capturing the roughness of the terrain. The deeply gouged drypoint marks create a sense of compressed energy while the rich burr and the use of plate-wiping evoke the force of the wind which has bent the trees into twisted shapes.

1 Roy Johnston, *The Prints of Roderic O'Conor* (1999), 13.

2 Caroline Boyle-Turner, *The Prints of the Pont-Aven School* (1986), 85.

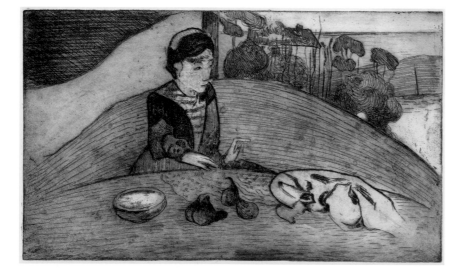

Armand Séguin after Paul Gauguin
La femme aux figues (*The woman with figs*)
Etching with aquatint, 26.8 × 44.5 cm
The British Museum, PD 1949,0411.2681,
bequeathed by Campbell Dodgson

WALTER F. OSBORNE (1859–1903)

The Flemish Cap, c. 1882

Etching, 21.4 × 15 cm

The British Museum, PD 1902,0107.22, donated by William Booth

In the autumn of 1881, having spent some five years studying at the Royal Hibernian Academy and the Dublin Metropolitan School of Art, Walter Osborne left Ireland with Nathaniel Hill and J.M. Kavanagh for the Académie Royale des Beaux Arts in Antwerp. They enrolled for the winter course and Osborne took classes with Charles Verlat, an animal and genre painter whose interest in etching was well known. This etching, signed 'F.W. Osborne 1882' in the plate, was most likely made in Antwerp along with his only other known print, a striking 'portrait' of a terrier with soulful eyes. Both etchings were gifted to the British Museum by William Booth Pearsall in 1902.

Despite the fact that Osborne was using an unfamiliar technique, these etchings are superb examples of his draughtsmanship. Both appear to be studies from life and have a liveliness created through the use of short, confidently etched lines. Only the roughness of the finish and the presence of random scratches point to the artist's lack of experience in handling etching plates. The study of a melancholic woman with downcast eyes wearing the traditional Flemish mob-cap is sensitively drawn. Osborne creates the folds of the cap through etched lines and burnishing out. A related painted sketch, *Modenke Verhoft*, depicts an old woman from Calmphout, a rural village outside Antwerp. It is likely Osborne used the same woman as the model for both print and painting.

Although Osborne's etchings are well realised, it seems that printmaking was simply a student digression from the business of painting. Although he exhibited regularly at the RHA annual exhibitions from 1877, he never showed any etchings, unlike his compatriot Kavanagh.

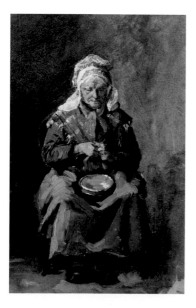

Modenke Verhoft, 1882

Oil on panel, 21.1 × 13.3 cm

NGI 1929, bequeathed, P. Sherlock, 1940

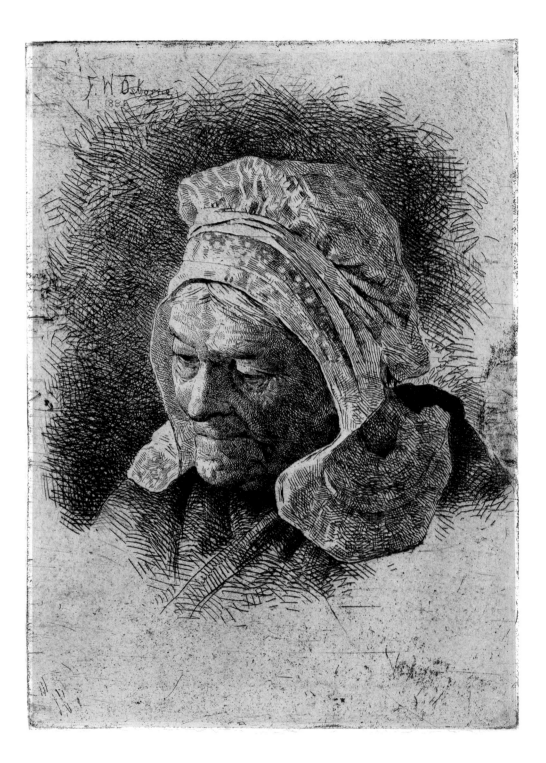

ESTELLA SOLOMONS (1882–1968)

McDaid's Pub, Dublin
Etching, 30.8 × 37.7 cm
Trinity College Dublin, TCD MS 11583/2018/15

Estella Solomons's considered exploration of urban themes in etching distinguishes her significantly from many of her contemporaries. In her etching entitled *McDaid's*, the carefully observed public house and other shop façades are animated by the inclusion of preoccupied figures. It is early morning and the viewer is drawn into the scene as it recedes and fades into the distance. Solomons illustrates the strength of the daylight by limiting the working of the plate surface, leaving expanses of wall and paved ground barely indicated. Like Whistler and his followers, she mastered the ability to combine crisp defining line, which is deliberate and assured, with finer suggestive marks which evoke mood and atmosphere.

Solomons's treatment of the scene is unsentimental as she captures the ambience and character of a mercantile area of the capital. In all her urban scenes she elected not to engage with people as individuals but rather remains respectfully distant. She is an observer, a *flâneuse*. Her depiction of the city's lower-class districts was noted in the press. A newspaper report stated that her work did not focus on the 'shabby' but that her images of a vanishing Dublin were imbued with 'tragic dignity'.[1] Solomons did not expose the harsh reality of tenement life, but rather recorded its spirited communities and the picturesque quality of its crumbling environments.

Other commentators recognised the etchings' value as artworks in themselves, claiming: 'These etchings of Old Dublin will be treasured by connoisseurs, not only of the fine work in them, but because they give us as no camera study can give us – the atmosphere and charm of places fast disappearing before the inroad of civic improvement'.[2] It could be argued that these rarely published or displayed prints may have appealed to a sense of nostalgia for the grandeur of colonial Dublin among some audiences. However, as Estella Solomons herself identified with the nationalist cause in Ireland, her own intention seems to have been to record the simple, yet heroic, everyday lives of Dublin's working classes. Her etched self-portrait is used as the frontispiece of this publication.

Mary Duncan and Frida Perrott were painters who were part of Estella Solomon's circle in the early 1900s. Etchings by both women were owned by Solomons and examples of their work are included in this exhibition.

1 *The Irish Times*, 3rd March 1919.

2 *The Irish Times*, 16th November 1925.

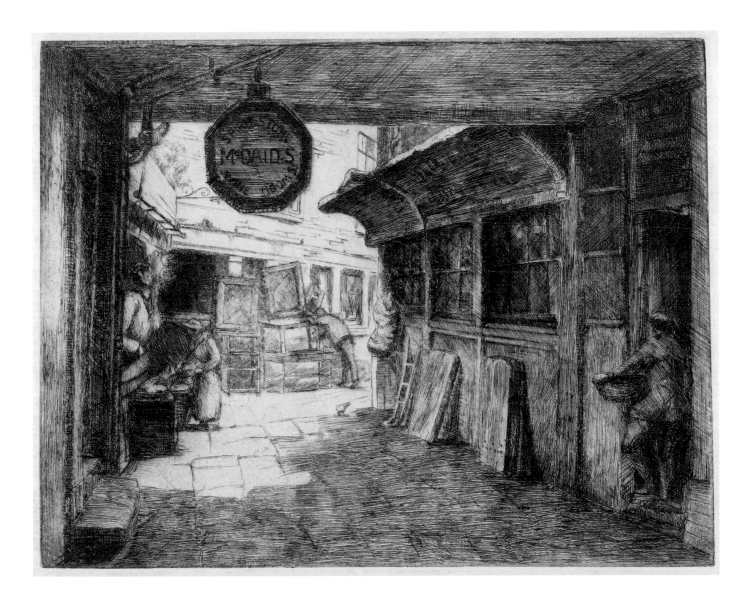

EDWARD MILLINGTON SYNGE (1860–1913)

Canal View in Venice, c.1902
Etching, 15.7 × 15.9 cm
The British Museum, PD 1949,0411.494, bequeathed by John Mavrogordato

Edward M. Synge was elected an associate member of the Royal Society of Painter-Etchers in 1898. There he became friendly with Francis Seymour Haden and Frank Short, who advised and guided his development as a printmaker. Like Gethin, Goff and Lawrenson, Synge travelled across Europe producing series of etchings in France, Italy and Spain. The majority of Synge's works held in public collections depict continental landscapes. Figures are rarely present in his work, and if included are incidental. Throughout, his approach is one of deliberate selection and omission. He adhered to Etching Revivalist principles of working *en plein air*, carefully choosing areas to highlight, often with drypoint, and other areas to merely suggest or omit. His early prints such as *Wheelwright's Shop* show the influence of Whistler's earlier *Thames Set* etchings, with its play on light and shade and carefully recorded details. In his later views Synge uses a greater economy of means, bringing a new sparseness to compositions such as *Canal View in Venice* in keeping with the direction taken by Whistler in the 1880s.

Carefully applied calligraphic lines, judiciously placed tonal areas and the dynamic arrangement of elements are among the most distinguishing features of the artist's work. The etchings made in Italy are Synge's most successful prints. His subtlety of approach and his personal interpretation of the subject add an expressive quality to the image. The sparse and spontaneous nature of this work, the finesse of his tonal range and the delicate but decisive detailing of the bridge and the gondolas, indicate that the image was produced in one sitting.

Synge was born in England to an Irish family and was a cousin of the playwright John Millington Synge.

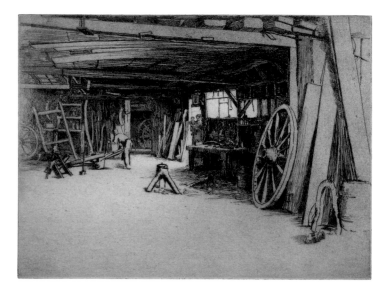

Wheelwright's Shop
Etching, 15.7 × 15.9 cm
The British Museum,
PD 1913,1111.8

FRANCIS S. WALKER (1848–1916)

St Paul's Cathedral in Moonlight, c. 1900

Etching and drypoint, 92 × 63 cm

The British Museum, PD 1919,0826.1, given by the artist's daughters

Born in County Meath, Francis Walker moved to London in 1868 to work as a wood-engraver for the Dalziel Brothers. He began making etchings around 1880. Although a member of the Royal Society of Painter-Etchers, Walker's approach to printmaking differed from that of exponents of the Etching Revival. Principal figures of the movement, such as Whistler and Haden, promoted realist themes and practices, including working directly from nature onto the prepared plate. His approach was much more in accordance with the highly finished and decorative style of early Victorian illustration in which he trained and worked.

St Paul's Cathedral in Moonlight is a typical example of Walker's work. It is impressively large, at odds with the more commonly produced domestic-sized prints. Pools of moonlight and punctuations of artificial light are reflected in the deep running waters of the Thames. A goods-laden barge enters from the lower left as the dome of St Paul's rises on the right. The rich detail of each suggests the artist spent much time sketching in the area, and may have used photographs. However, the night-time atmosphere of emerging shadows and city hazes is dramatised, in keeping with Walker's experiences in literary illustration. All areas of the image are heavily worked-up; every part of the plate is marked by the artist. The printing is masterful, the surface tone artistically manipulated by the leading professional printer of the day, Frederick Goulding.

Walker's somewhat archaic style reflected the contemporary popularity of Joseph Mallord William Turner's mezzotints following the successful issue by Frank Short of the remaining unpublished plates for Turner's *Liber Studiorum* in the late 1880s.[1] In his prints, Walker was appealing to this market by creating works in the style and spirit of British art of the late eighteenth and early nineteenth century. *St Paul's Cathedral in Moonlight* was included in Walker's submission to the Irish International Exhibition of 1907.

1 Rodney K. Engen, *Dictionary of Victorian Engravers, Print Publishers and their works* (1979), 177.

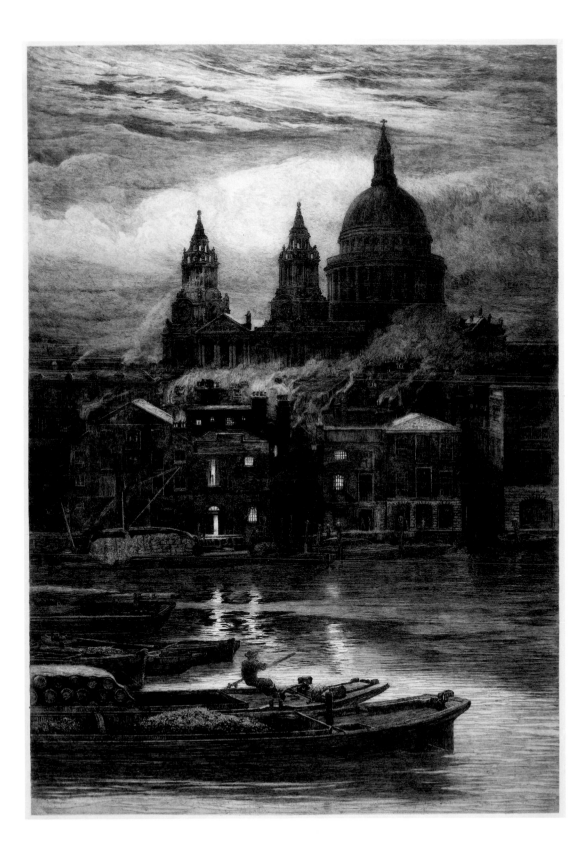

GLOSSARY

Aquatint
An intaglio (qv) method used to create tone and texture. Minute particles of resin are applied in powder form to selected areas of a metal plate. The powder hardens into acid-resistant grains which adhere to the plate when exposed to heat. When the plate is placed in an acid bath, only the areas around the grains are etched, resulting in a textured / tonal effect when the plate is inked and printed.

Artist's print
Prints created by a fine artist. The term is used interchangeably with 'original print' to distinguish them from reproductive prints made after an artist's work and cut by a professional engraver.

Bite
The corrosive effect of acid on a metal plate.

Burin
An engraving tool with a square or lozenge-shaped shaft attached to a wooden handle, used on metal or wood. Also referred to as a graver.

Burnisher
A tool used to smooth roughness on a metal plate to create lighter areas when printed.

Burr
The ridge of metal which gathers on either side of a cut line created by a drypoint (qv) needle. When inked and printed, this creates a rich, velvety line.

Coloured prints
Implies that colour (often watercolour) was added by hand after printing.

Colour prints
Indicates that colour was added during the printing process. In one method multiple plates are used, a separate plate for each colour to be printed. The second method involves colour being applied *à la poupée*. Coloured inks are pressed into the individual areas of the plate with a rag or *poupée*, the printer taking great care not to smudge the edges of each area of colour.

Copperplate
Traditionally the most common metal used for etching was copper. Etchings are sometimes referred to as copperplate prints.

Drypoint
An intaglio (qv) technique where no acid is used. The artist draws directly onto the surface of the plate by scratching with a sharp needle, creating a burr (qv). It is a more instinctive, creative technique in comparison to professional engraving (qv). The plates wear down quickly and as a result only a small edition (qv) is produced.

Edition
A development associated with the Etching Revival from the mid-nineteenth century. Limited numbers of prints were produced from a block, plate or lithographic stone, not due to wear and tear of the matrix (qv), but to emphasise the artistry of fine art printmaking compared to mass-produced reproductive prints. Once the artist printed the full edition, the plate, block or stone was defaced or cancelled.

Engraving
The oldest intaglio (qv) method, produced by cutting a metal plate directly, in a controlled manner with a sharp engraving tool, known as a burin (qv). This technique was popular for commercial illustration and reproductive prints after paintings.

Etching
An intaglio (qv) technique; the word derives from Dutch, and means 'to eat'. The back of a metal plate, commonly copper (other metals used include zinc), is protected with a layer of varnish or bitumen and the front is covered with an acid-resistant ground, usually made of wax. The artist, using a pointed tool, draws an image by cutting through the wax ground. The plate is then immersed in an acid bath which etches or eats into the exposed metal. These etched lines vary in depth and width depending on the tools used and the length of time the plate is left in the acid. When the plate is inked, the ink is carried in the etched lines.

Ground
An acid-resistant substance which protects the plate from the action of acid during etching and aquatint processes.

Ink

Printing ink is oil based and is quite distinct from writing ink. Oil is added to a finely ground pigment, such as lamp black. Its viscous consistency prevents run-off when applied to the engraved or etched lines in intaglio (qv) printing.

Intaglio

Print processes which use metal plates including engraving (qv), etching (qv), mezzotint (qv) and drypoint (qv). The lines to be printed are cut into the metal surface and ink gathers in these lines.

Matrix

A sheet of metal, stone or block of wood from which a print is pulled.

Mezzotint

An intaglio (qv) technique which does not employ acid. Mezzotint is a time-consuming method of achieving tone where the artist works from dark to light. The plate is roughened with a mezzotint rocker or roulette to create a surface pitted with tiny stippled marks which if inked would print pure black. The artist then works into the plate by burnishing back into the roughened surface by scraping and polishing. Areas which are partially flattened will produce greys when printed and areas completely flattened and smoothed will not carry ink, leaving the printed paper white.

Plate mark

Imprint of the plate edge in an intaglio (qv) print created by the pressure of the printing press.

Press

An intaglio (qv) printing press used for engraving and etching. The inked plate and a sheet of dampened paper are passed through two rollers under considerable pressure, forcing the ink in the cut lines of the plate onto the paper.

Proof

In the strictest sense a proof refers to any impression from a plate. Other terms include 'artist's proofs' or 'collector's proofs', which were made outside the original edition. These terms aided the marketing of prints. Some artists created special proofs, such as works printed on handmade

paper, or the artist may have printed that particular proof themselves, rather than using a professional printer. This information was written on the print, usually below the image along with the artist's signature and title. The number of the print within the edition was also listed.

Registration
The precise alignment of separate plates or blocks used in colour printing.

Retroussage
A technique used in intaglio (qv) processes where the inked plate is wiped to soften the inked lines before printing.

Rocker
A tool used for mezzotint (qv) which is made up of a wide curved and serrated metal edge with a handle.

Roulette
A wheeled tool sometimes used in etching to create dots.

State
A proof of a plate at a certain stage in the printing process. Subsequent work on the plate results in a new state of the print being created. There can be multiple 'states' of one print.

Surface tone
Visible traces of ink left on unworked areas of an intaglio (qv) print. Tone is deliberately produced by leaving a thin layer of ink on the plate when wiped.

PRINTS IN THE EXHIBITION
Irish Painter-Etchers

All works are on paper unless noted otherwise, sheet dimensions noted

GEORGE ATKINSON
(1880–1941)
Shannon Scheme No. 1: Keeper Mountain, 1929
Etching, 35 × 41.5 cm
Crawford Art Gallery, CAG.277

Shannon Scheme No. 2: The Culvert, 1929
Etching, 35 × 41.5 cm
Crawford Art Gallery, CAG.3026

Shannon Scheme No. 3: The Excavations, 1929
Etching, 50.2 × 64.4 cm
Crawford Art Gallery, CAG.3027

The Bells of Shandon, Cork
Etching, 32.5 × 20 cm
Crawford Art Gallery, CAG.2028

The Nun's Garden, c.1910
Etching, 11.5 × 21.2 cm
Hugh Lane Gallery, Reg. No.414

Ponte Vecchio
Etching, 25.4 × 30.5 cm
Hugh Lane Gallery, Reg. No.415

WILLIAM BOOTH PEARSALL
(1845–1913)
Sir John Rogerson's Quay, c. 1880
[From *Eighteen Facts and Fancies in Needlework*]
Etching, 22.6 × 28.8 cm
National Library of Ireland, 767 f 1

MARY DUNCAN (1885–1964)
Rear View of a House
Etching, 19.8 × 16.8 cm
Trinity College Dublin,
TCD MS 11583/2018/21

WILLIAM FITZGERALD
(dates unknown)
Mendicant Tinker, c.1880
Etching, 22.5 × 20 cm
NGI 20785, presented, William Booth Pearsall, 1902

Low Water, 1885
Etching, 14 × 23 cm
NGI 20786, presented, William Booth Pearsall, 1902

A Fisherman on a Pier
Etching, 22.5 × 20.5 cm
NGI 20773, presented, William Booth Pearsall, 1902

PERCY F. GETHIN (1874–1916)
South German Farm, 1909
Etching, 27 × 34 cm
NGI 11869, presented, Mrs G. Lane, 1919

Bending the Jib, c. 1912
Etching and aquatint with drypoint, 25.3 × 18.7 cm
The British Museum, PD 1924,0209.18, donated by The Contemporary Art Society

Peat Bog, 1912–13
Drypoint, 21.5 × 25 cm
NGI 11480, presented, Fred Burridge through Sarah Purser, 1926

Musicians, 1912–13
Etching, 30.8 × 28 cm
NGI 11428, presented, Fred Burridge through Sarah Purser, 1926

Travelling Circus, County Clare, 1912–13
Etching, 21.2 × 25.5 cm
NGI 11619, presented, Fred Burridge through Sarah Purser, 1926

ROBERT C. GOFF (1837–1922)
Shipbuilding, Viareggio, Tuscany, c.1904
Etching, 19 × 23.5 cm
NGI 2011.8, purchased, 2011

Doge's Palace, Venice, c. 1903
Etching, 14.1 × 19.8 cm
NGI 11871, provenance unknown

SARAH CECILIA HARRISON (1863–1941)
Study of a Man's Head, c.1880
Etching, 20 × 15 cm
Hugh Lane Gallery, Reg. No.430

MYRA HUGHES (1877–1918)
Sackville Street, c.1910
Etching, 15.9 × 16.2 cm
The British Museum, PD 1919,0528.8, given by the family of the late Myra Hughes through Mary C. Hamilton

Holy Sepulchre, Jerusalem, 1917
Etching, 32.3 × 19.2 cm
The British Museum, PD 1919,0528.11, given by the family of the late Myra Hughes through Mary C. Hamilton

View from Examination Hall, TCD, c.1912
[from the portfolio of five etchings of Trinity College, Dublin]
Etching, 34 × 42.8 cm
Trinity College Dublin, OLS Papyrus Case 132

JOSEPH MALACHY KAVANAGH (1856–1918)
Palingbrug, Antwerp, 1883
Etching and drypoint, 19.5 × 13.5 cm
NGI 20861, bequeathed, Mrs K. Baskerville, the artist's grand-niece, 1997

On the Ramparts, Mont St Michel, 1885
Etching and drypoint, 21.5 × 13.5 cm
NGI 20862, bequeathed, Mrs K. Baskerville, the artist's grand-niece, 1997

JOHN LAVERY (1856–1941)
Two Figures in a Boat, 1883
Etching, 28.7 × 14.9 cm
NGI 2017.49, purchased, 2017

EDWARD L. LAWRENSON (1868–1940)
The Dublin Bottlemakers, 1903
Colour aquatint and etching, 22.6 × 30.4 cm
The British Museum, PD 1924,1202.5

Moonlit View with a Caravan, c.1910
Etching and aquatint, 27.6 × 37.7 cm
The British Museum, PD 1977,U.1148

Gordale Scar, 1912
Colour aquatint and soft ground etching, 50.3 × 66 cm
Hugh Lane Gallery, Reg. No.635

Sognefjord, 1924
Colour aquatint and soft ground etching, 30.3 × 40.2 cm
The British Museum, PD 1924,1112.7

RODERIC O'CONOR (1860–1940)
Coastal Landscape, 1893
Etching and drypoint with roulette, 20 × 28.6 cm
NGI 2009.20, purchased, 2009

Landscape with Dark Trees and a River, 1893
Etching and drypoint, 44.5 × 30.5 cm
NGI 2009.19, purchased, 2009

Portrait of a Peasant, 1893
Etching and drypoint, 44.5 × 30.5 cm
NGI 2009.21, purchased, 2009

WALTER F. OSBORNE (1859–1903)
The Flemish Cap, c.1882
Etching, 21.4 × 15 cm
The British Museum, PD 1902,0107.22, donated by William Booth

FRIDA PERROTT (d.1946)
Portrait of Estella Solomons
Etching, 19 × 14.5 cm
Trinity College Dublin,
TCD MS 11583/2018/23

ESTELLA SOLOMONS (1882–1968)

McDaid's Pub, Dublin
Etching, 30.8 × 37.7 cm
Trinity College Dublin,
TCD MS 11583/2018/15

Self-Portrait
Etching, 19.9 × 19.2 cm
Trinity College Dublin,
TCD MS 11583/2018/19

Dublin Scene: Archway
Etching, 28.9 × 23.8 cm
Trinity College Dublin,
TCD MS 11583/2018/3

Dublin Shopfront
Etching, 19.6 × 28.6 cm
Trinity College Dublin,
TCD MS 11583/2018/5

Dublin Alleyway
Etching, 20.2 × 19 cm
Trinity College Dublin,
TCD MS 11583/2018/11

Winetavern Street, Dublin
Etching, 28.9 × 23.8 cm
Trinity College Dublin,
TCD MS 11583/2018/4

Cottages, Ireland
Etching, 12.3 × 20.9 cm
Trinity College Dublin,
TCD MS 11583/2018/8

Kings Inns, Dublin
Etching, 23.5 × 28.8 cm
Trinity College Dublin,
TCD MS 11583/2018/12

City Quay, Dublin
Etching, 23.8 × 30.5 cm
Trinity College Dublin,
TCD MS 11583/2018/13

Portrait of Seumas O'Sullivan
Etching, 25.7 × 23.3 cm
Trinity College Dublin,
TCD MS 11583/2018/20

EDWARD MILLINGTON SYNGE (1860–1913)

Canal View in Venice, c.1902
Etching, 15.7 × 15.9 cm
The British Museum, PD 1949,0411.494,
bequeathed by John Mavrogordato

Wheelwright's Shop
Etching, 15.7 × 15.9 cm
The British Museum, PD 1913,IIII.8

The Valley of the Var
Etching, 23.2 × 37.8 cm
The British Museum, PD 1913,0912.15,
donated by Edward Millington Synge

FRANCIS S. WALKER (1848–1916)

St Paul's Cathedral in Moonlight, c. 1900
Etching and drypoint, 92 × 63 cm
The British Museum, PD 1919,0826.1,
given by the artist's daughters

Thames; from Oxford to the Tower, 1891
[Etching by Walker in the above book]
Etching and drypoint, 29 × 45.7 cm
(book)
Trinity College Dublin,
Gall.15.b.41 124 LO

Mountain Landscape
[Etching in *Killarney's Lakes and Fells*, 1891]
Engraving, etching and mezzotint,
27 × 37.5 cm (book)
National Library of Ireland, NLI D45

Influential Printmakers

FRANCIS SEYMOUR HADEN (1818–1910)
A River in Ireland, 1864
Etching, 24 × 35 cm
The British Museum, PD 1910,0421.81

A Watermeadow, 1859
Etching, 17.4 × 24.8 cm
Hugh Lane Gallery, Reg. No. 449

ALPHONSE LEGROS (1837–1911)
Triumph of Death, c.1880
Etching, 25.2 × 28.8 cm
NGI 11475, presented, Sarah Cecilia
Harrison, 1904

ARMAND SÉGUIN (1869–1903)
La femme aux figues (after Paul Gauguin)
Etching with aquatint, 26.8 × 44.5 cm
The British Museum, PD 1949,0411.2681,
bequeathed by Campbell Dodgson

FRANK SHORT (1857–1945)
Swalecliffe Gap, 1913
Etching, 58.8 × 43.4 × 2 cm
The Hunterian: University of Glasgow,
GLAHA:2637

WALTER SICKERT (1860–1942)
Noctes Ambrosianae, c.1908
Etching and aquatint, 29.8 × 39.2 cm
NGI 11438, presented, The Sickert Trust,
1947

La Gaité Montparnasse, c.1919
Etching, 23.3 × 15.1 cm
NGI 11442, presented, The Sickert Trust,
1947

'O Sole Mio', c.1920
Etching, 39.4 × 32.2 cm
NGI 11439, presented, The Sickert Trust,
1947

WILLIAM STRANG (1859–1921)
Reverend William Delaney S.J., 1910
Etching, 38.7 × 32.4 cm
The Hugh Lane Gallery, Reg. No. 453

JAMES ABBOTT MCNEILL WHISTLER (1834–1903)
Eagle Wharf, 1859
Etching, 58.8 × 43.4 × 2 cm
The Hunterian: University of Glasgow,
GLAHA: 46731

Nocture: Furnace, 1880
Etching, 58.8 × 43.4 × 2 cm
The Hunterian: University of Glasgow,
GLAHA: 46875

ACKNOWLEDGEMENTS

The success of an exhibition of this kind involves collaboration, goodwill and advice from many quarters. We are grateful for the generosity shown by museums in both Ireland and the UK in terms of loans. We wish to thank our friends and colleagues in the institutions below:

Crawford Art Gallery

Hugh Lane Gallery

National Gallery of Ireland

National Library of Ireland

The British Museum

The Hunterian: University of Glasgow

Trinity College Dublin, the University of Dublin
- The Library
- Department of Early Printed Books and Special Collections
- Manuscripts and Archives
- The Irish Art Research Centre (TRIARC)
- Department of the History of Art and Architecture

A special word of thanks to these individuals whose help and support was invaluable:

Peter Black, Ewelina Bykuc, Hugo Chapman, Sandra Collins, Sarah Conroy, Barbara Dawson, Joanne Drum, Lydia Ferguson, Les Gosnell, Antony Griffiths, Roy Hewson, Elenor Ling, Niamh MacNally, Brendan Maher, Jane Maxwell, Mary McCarthy, Claire McDonagh, Lynn McGrane, Niamh McGuinne, Louise Morgan, Susan O'Connor, Jean O'Donovan, Chris O'Toole, Sean Rainbird, Sinead Rice, Philip Roe, Brendan Rooney, Steph Scholten, Yvonne Scott, Laura Shanahan, Helen Shenton, Mia Shirreffs, Logan Sisley, Kim Smit, Susan Solomons and the Solomons family, Tony Waddingham and Adriaan Waiboer.

Angela Griffith and Anne Hodge

This book is published on the occasion
of the exhibition:

Making their Mark:
Irish Painter-Etchers 1880–1930

National Gallery of Ireland, Dublin,
2 March–30 June 2019

ISBN 978-1-904288-75-6

Front cover image: detail from
Edward L. Lawrenson, *Sognefjord*, 1924,
The British Museum

Back cover image: George Atkinson,
Shannon Scheme No. 3: The Excavations,
1929, Crawford Art Gallery

Design by Tony Waddingham